the little monsters tarot
coloring book

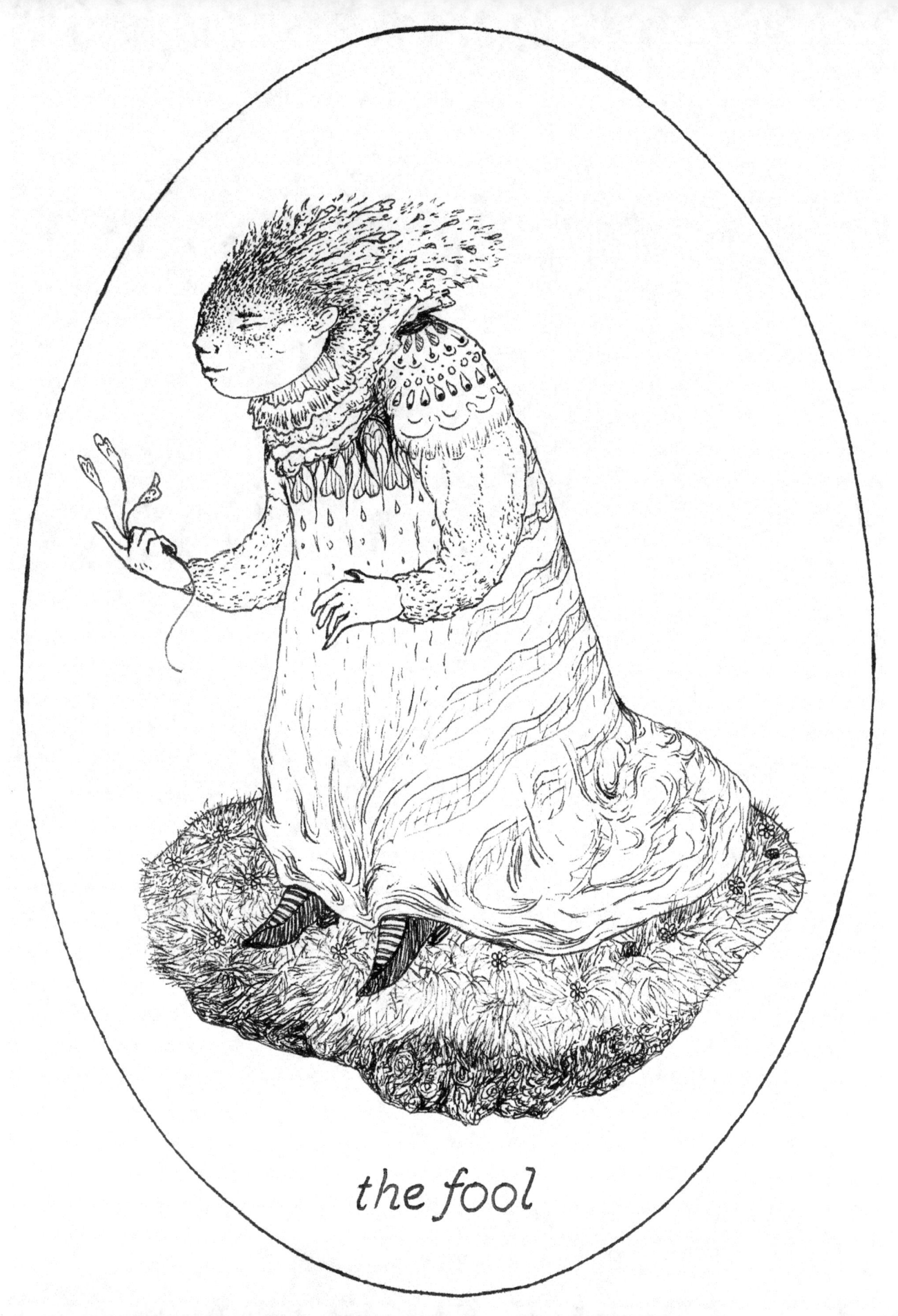

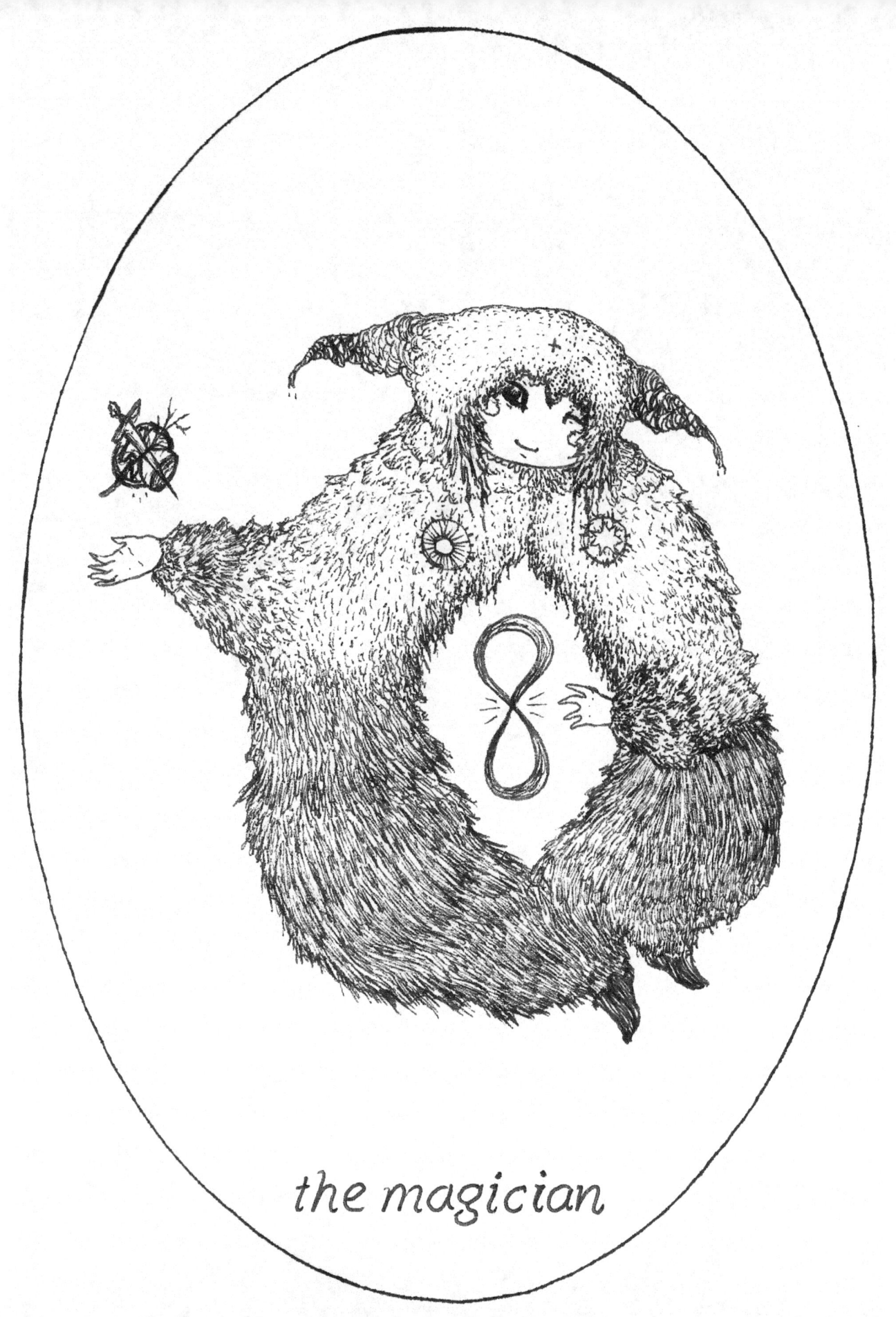

the magician

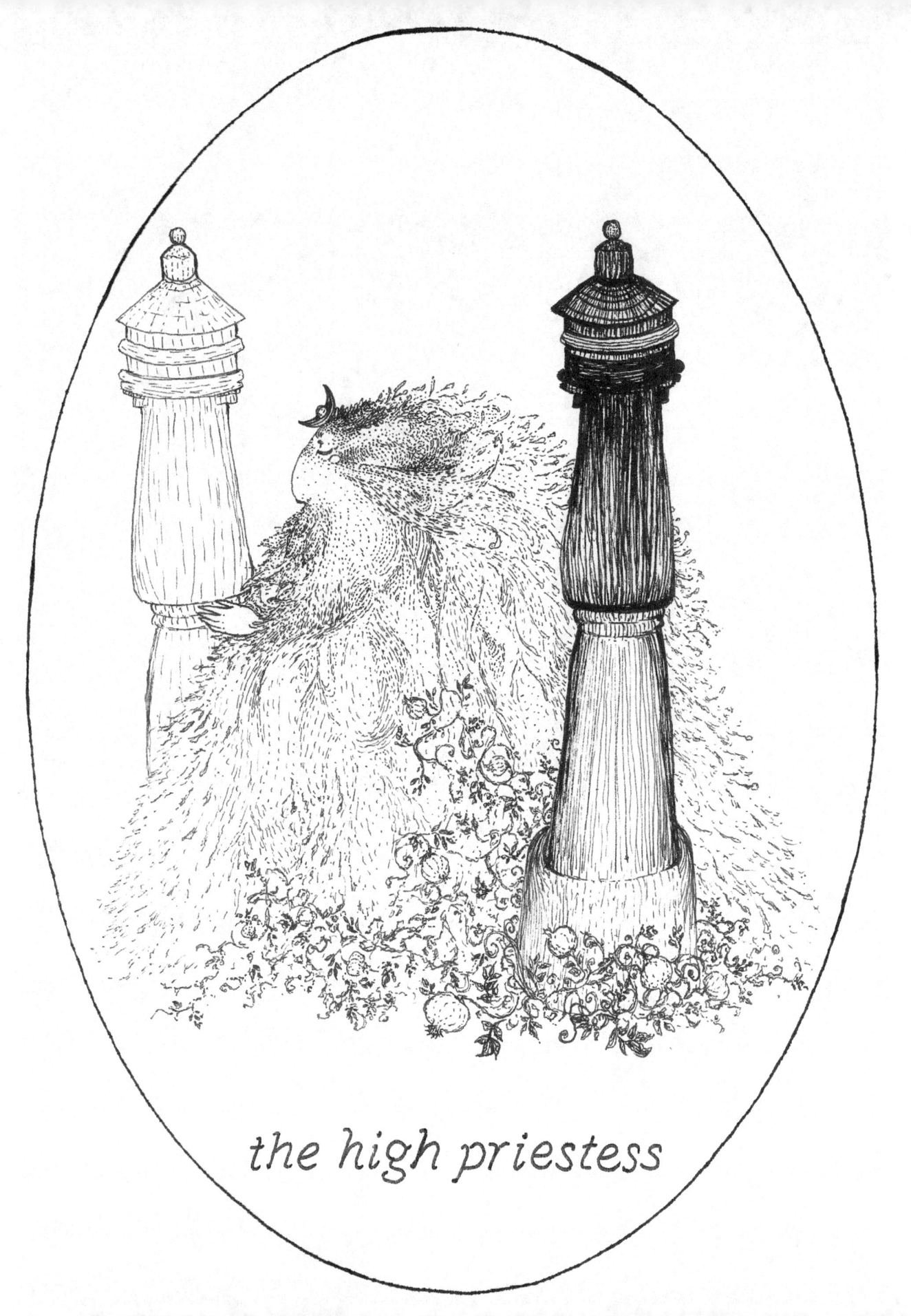

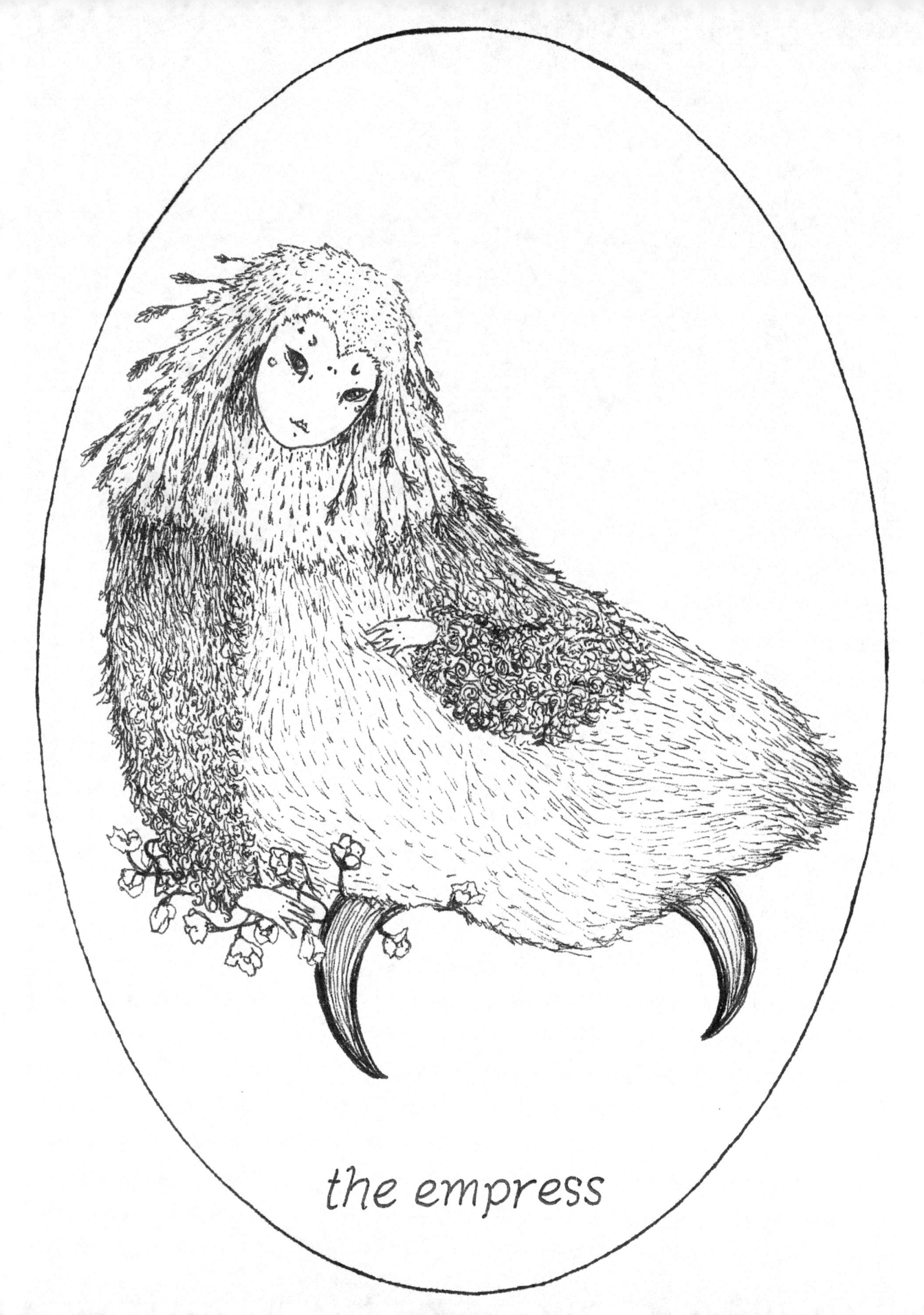

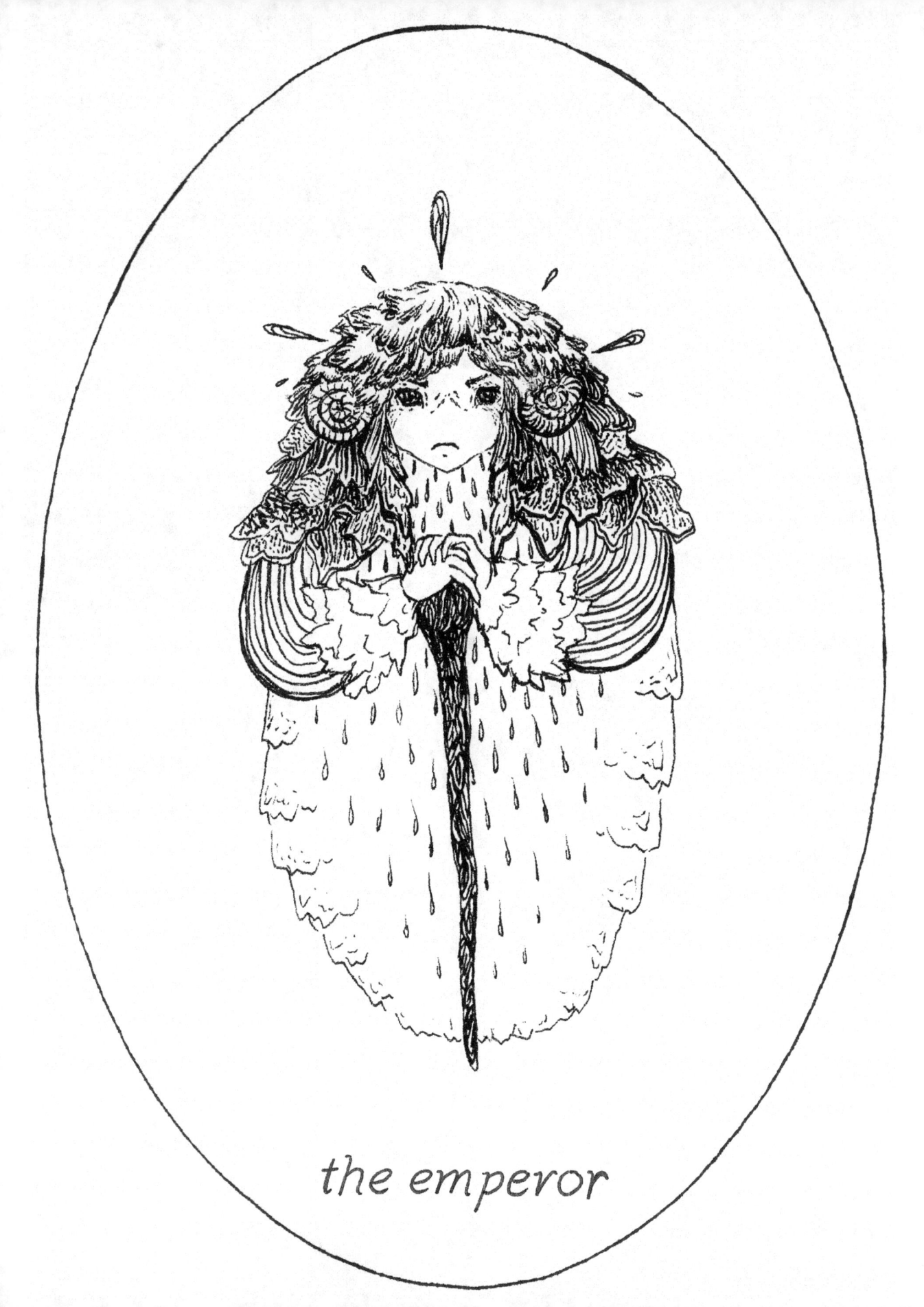

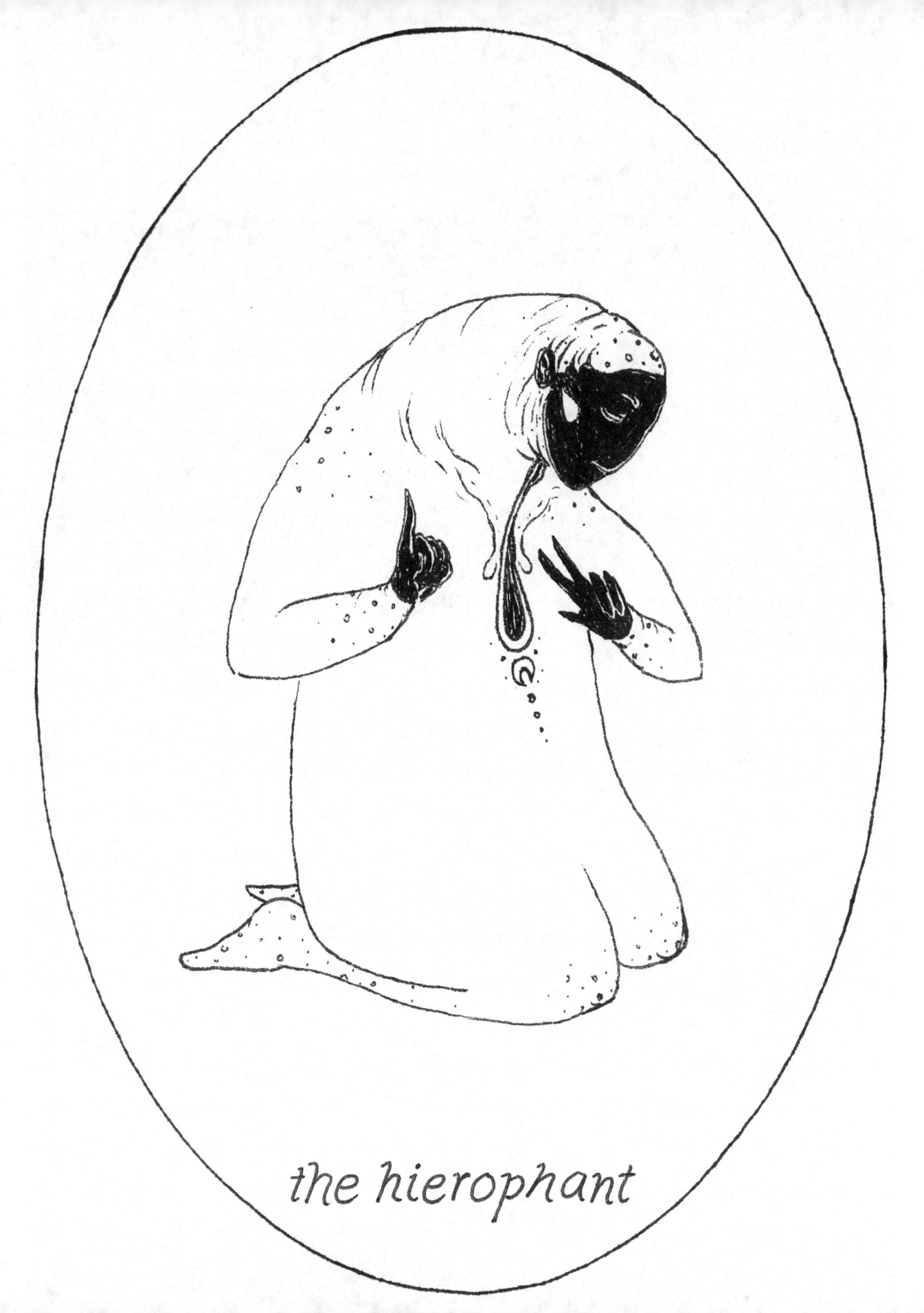

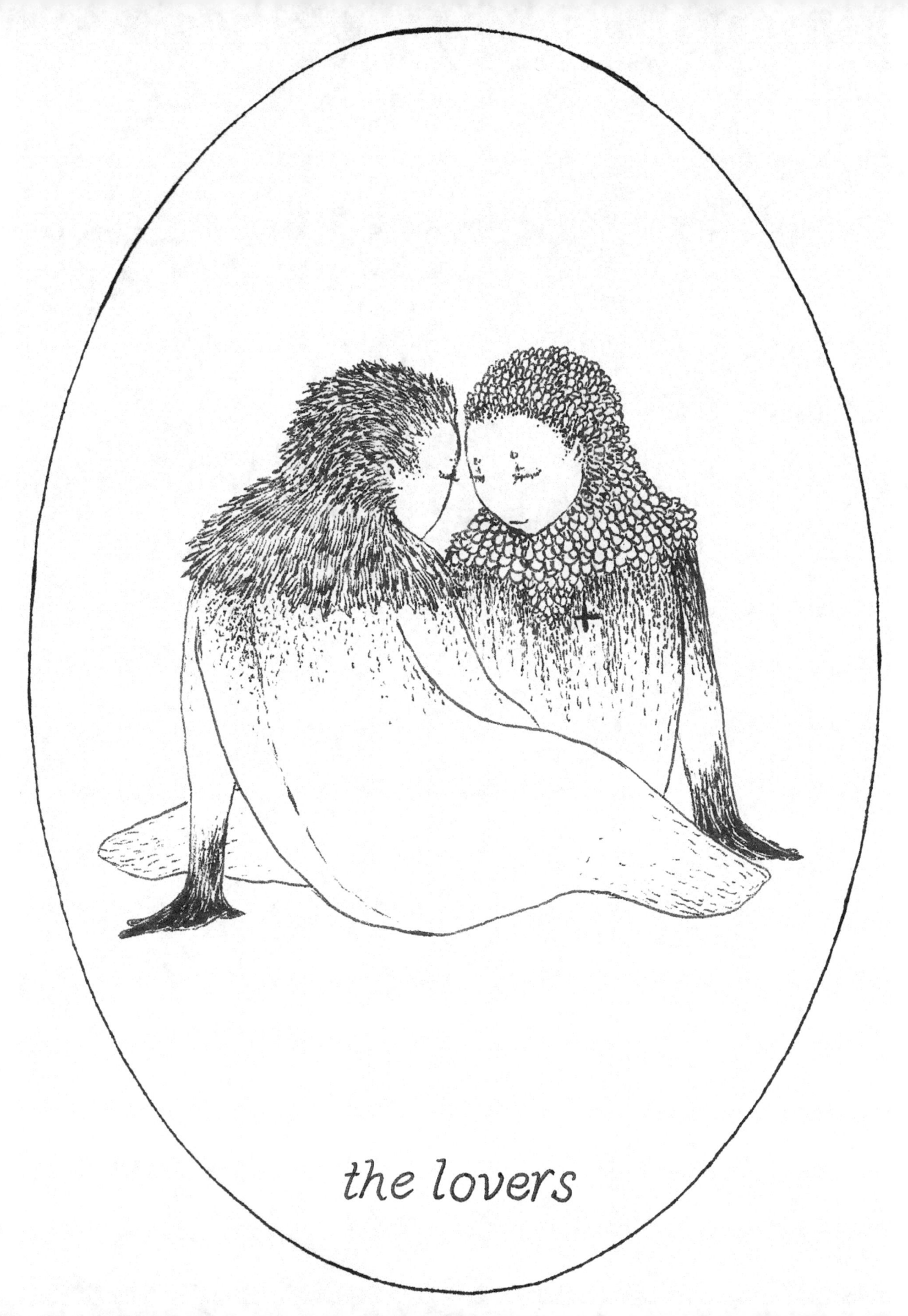

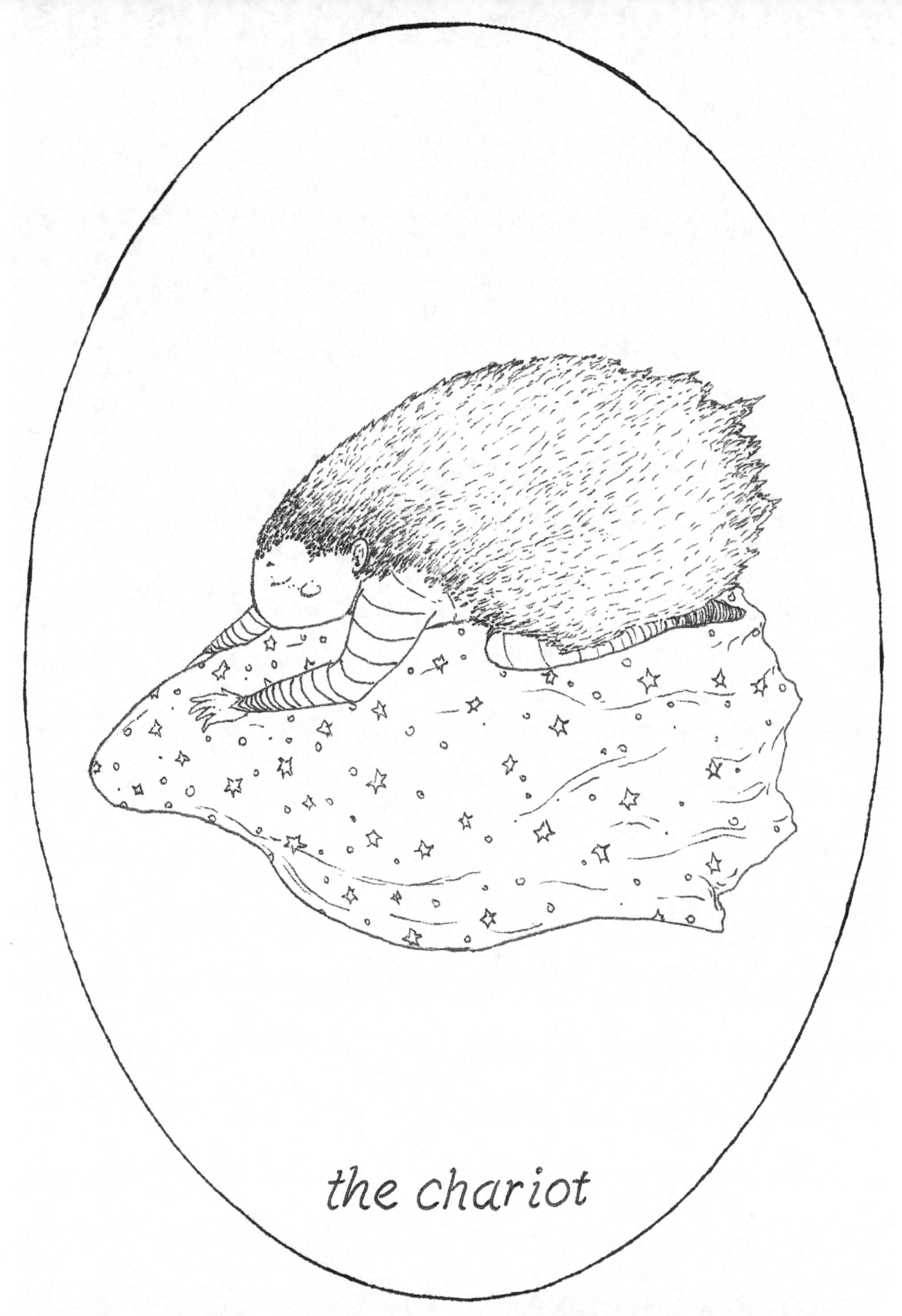

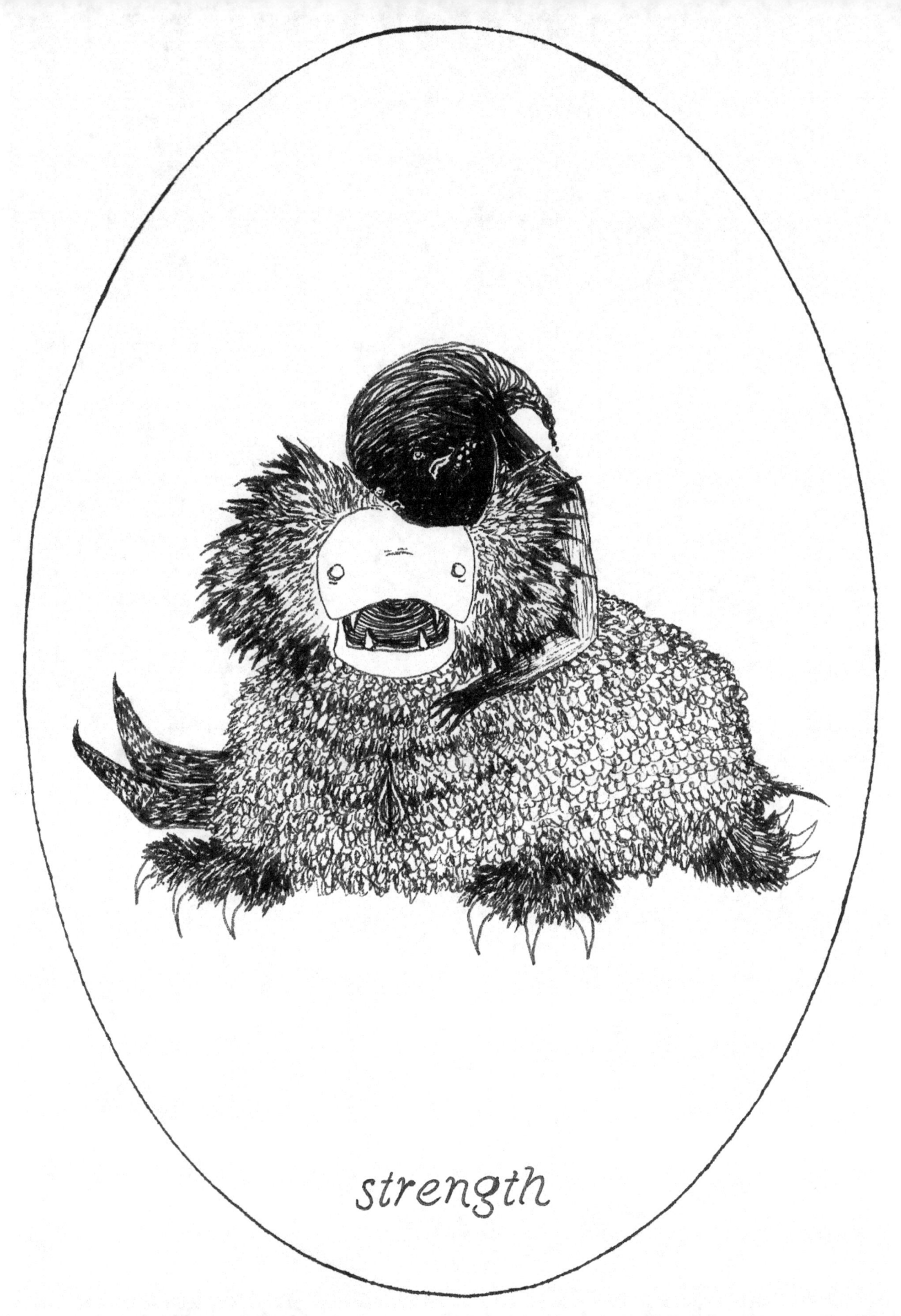

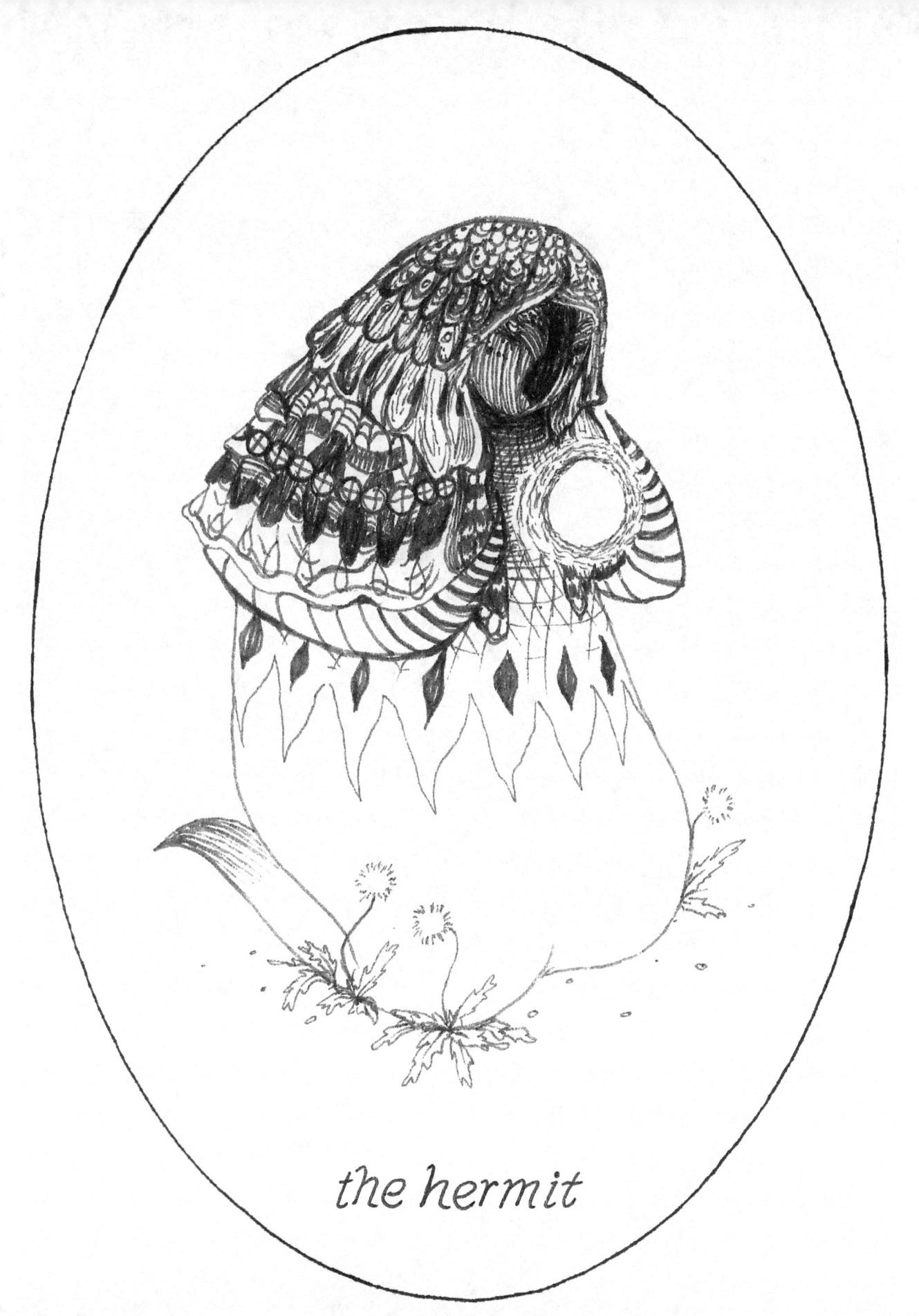

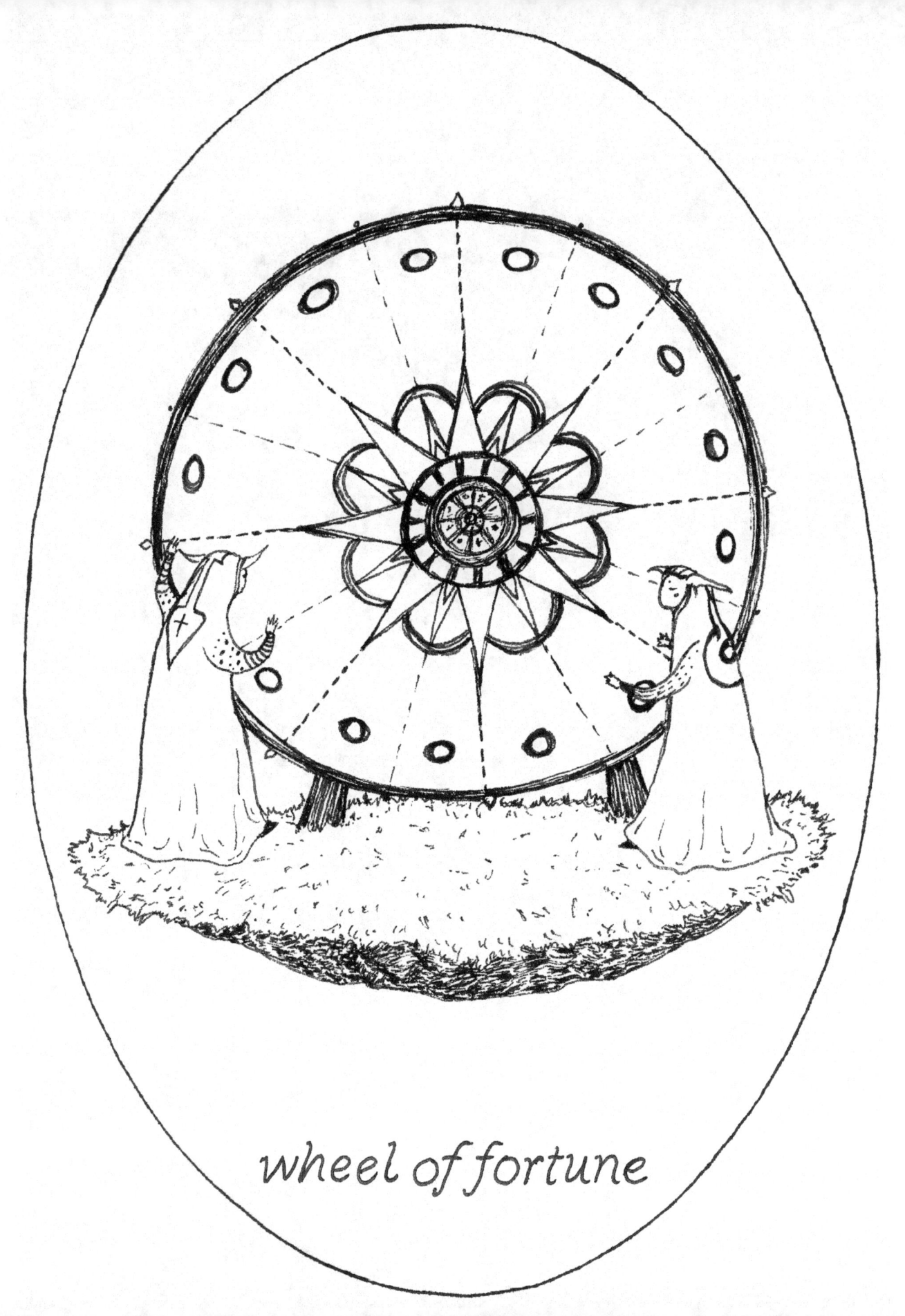

wheel of fortune

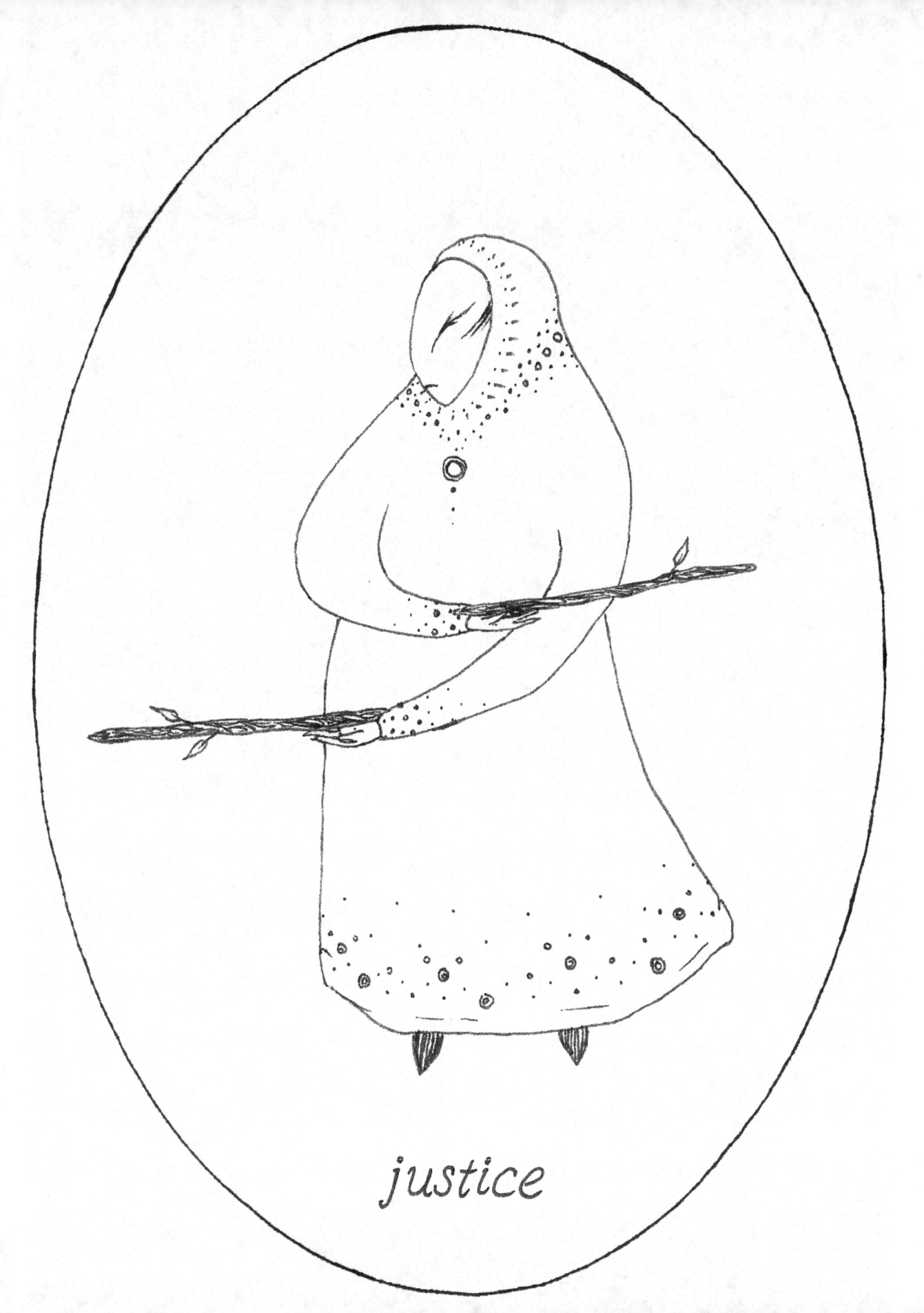

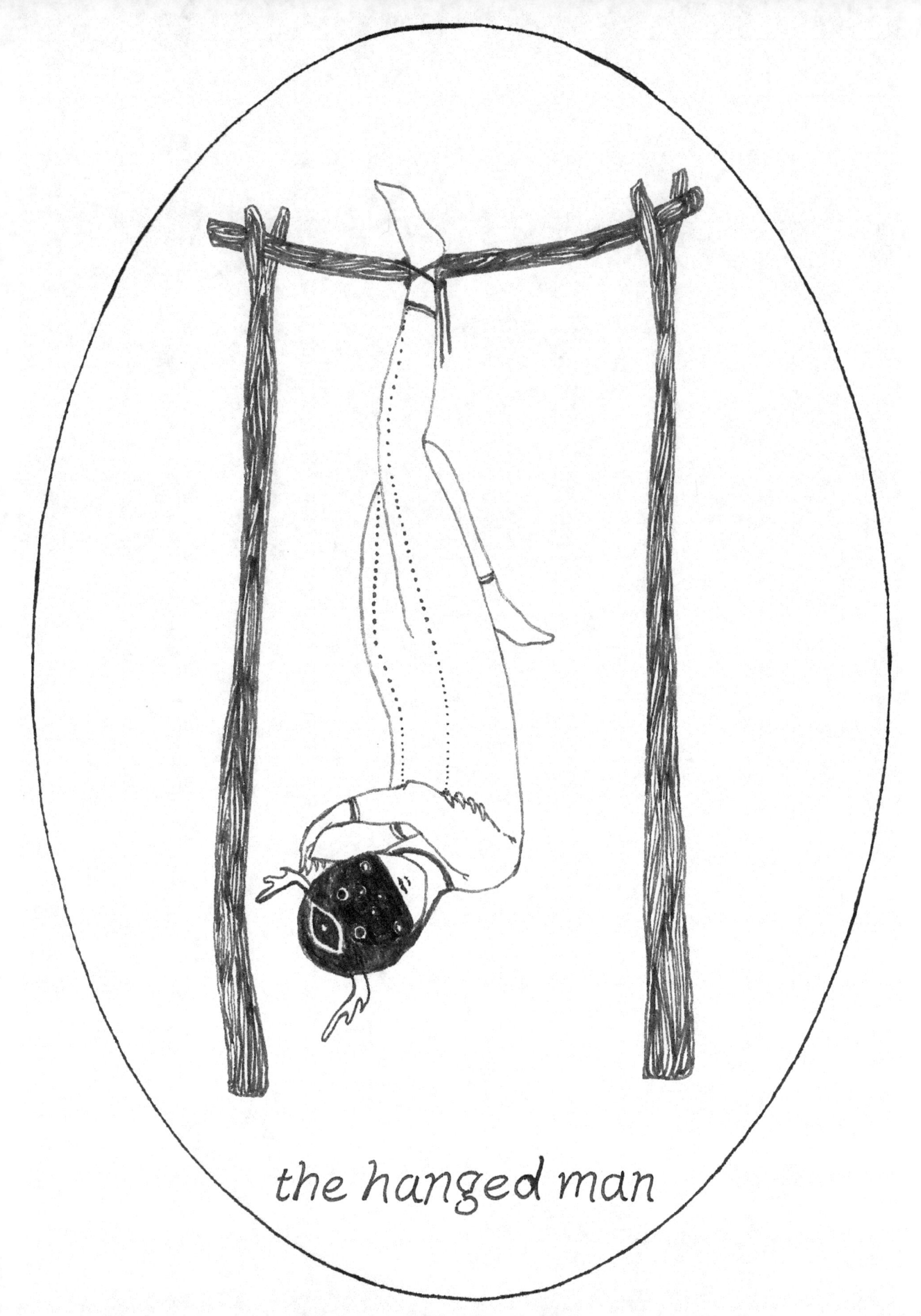

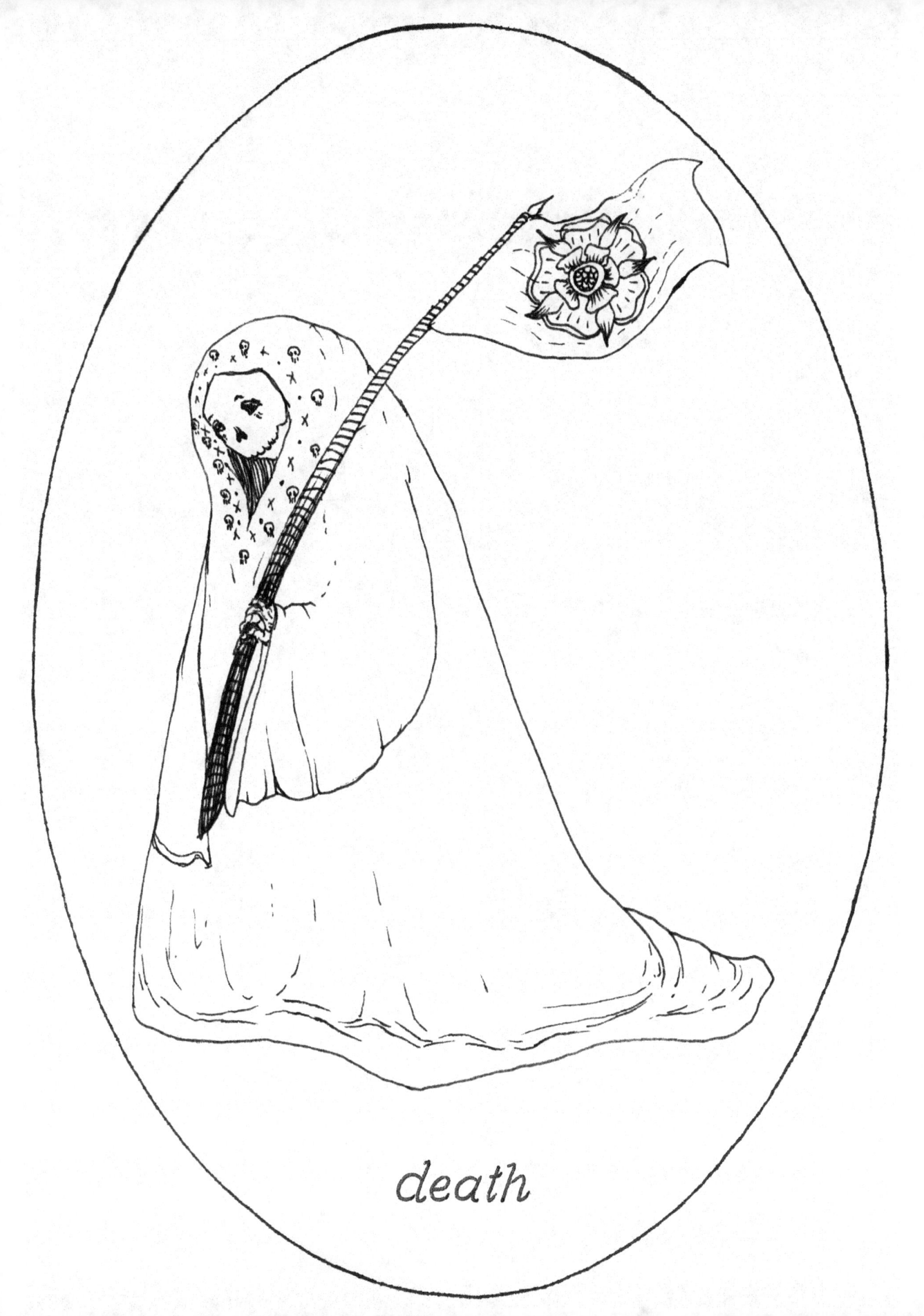

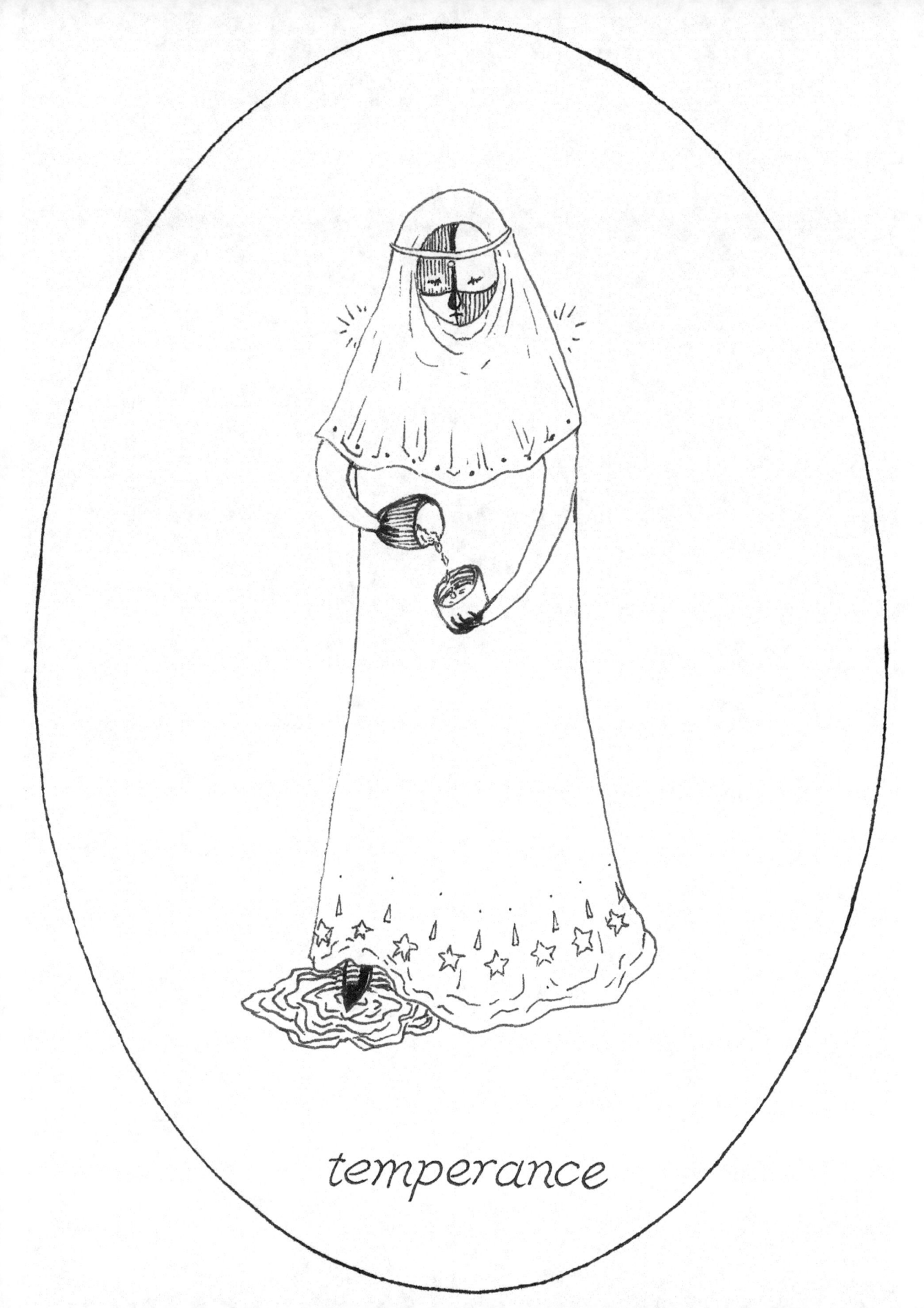

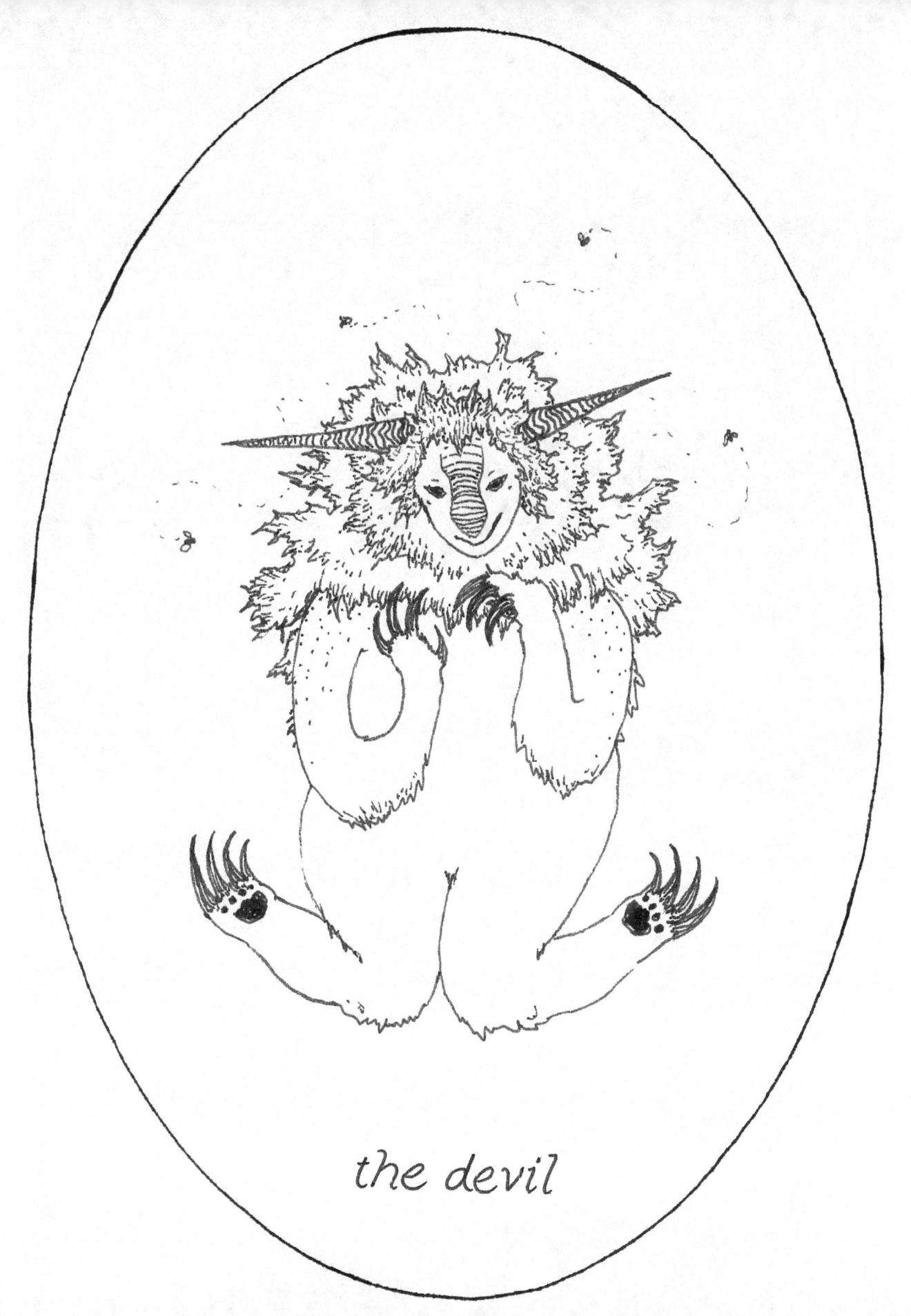

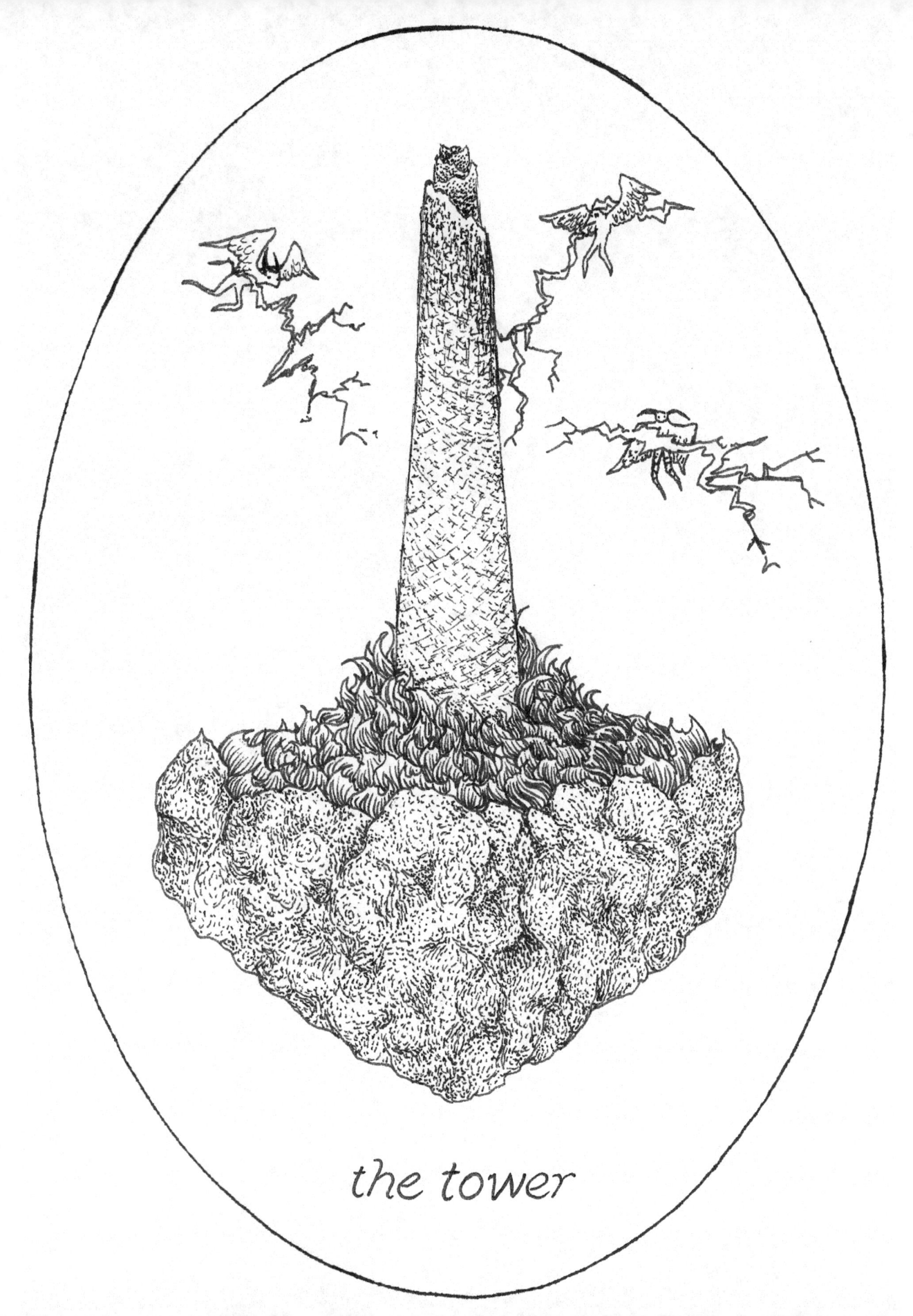

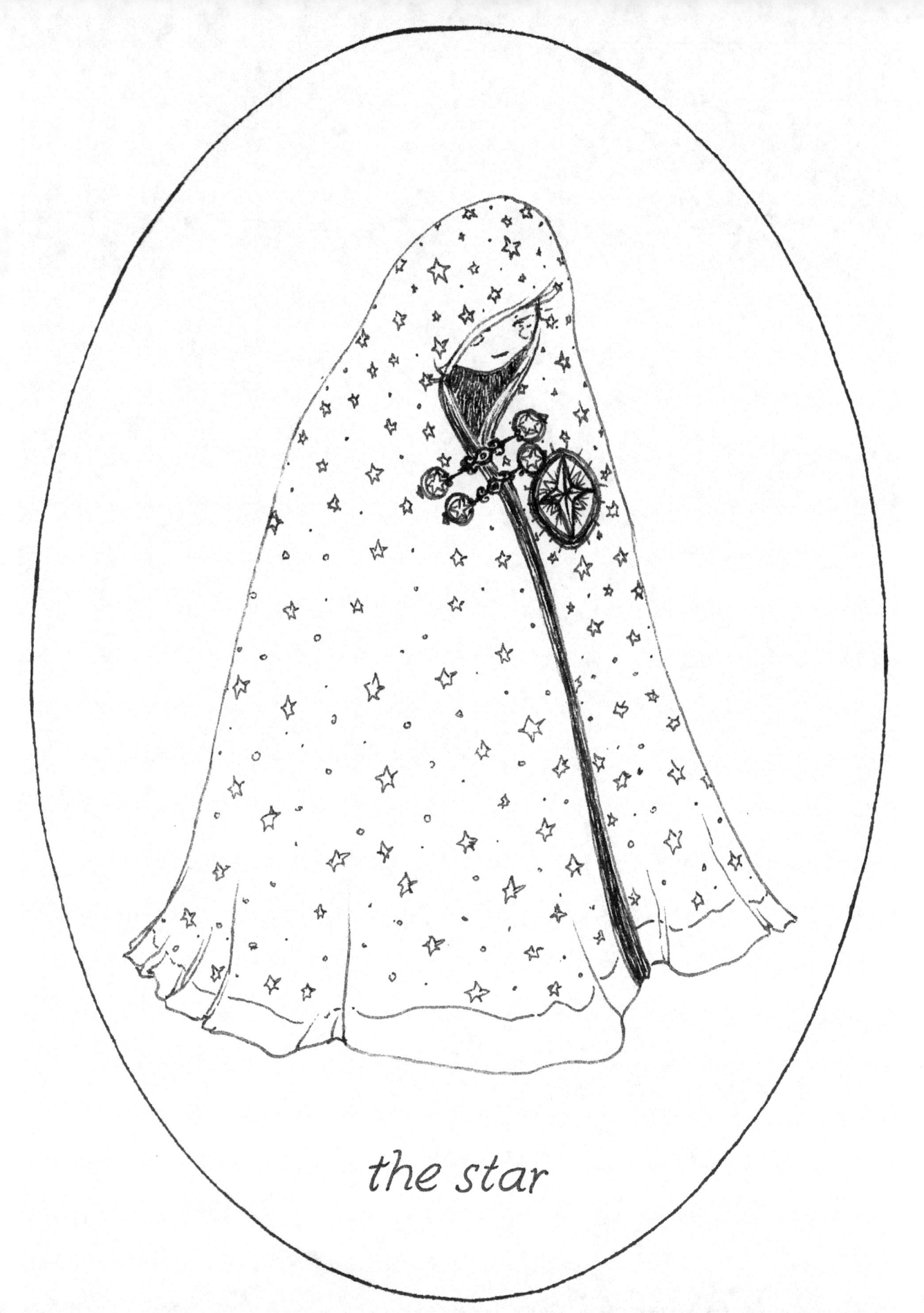

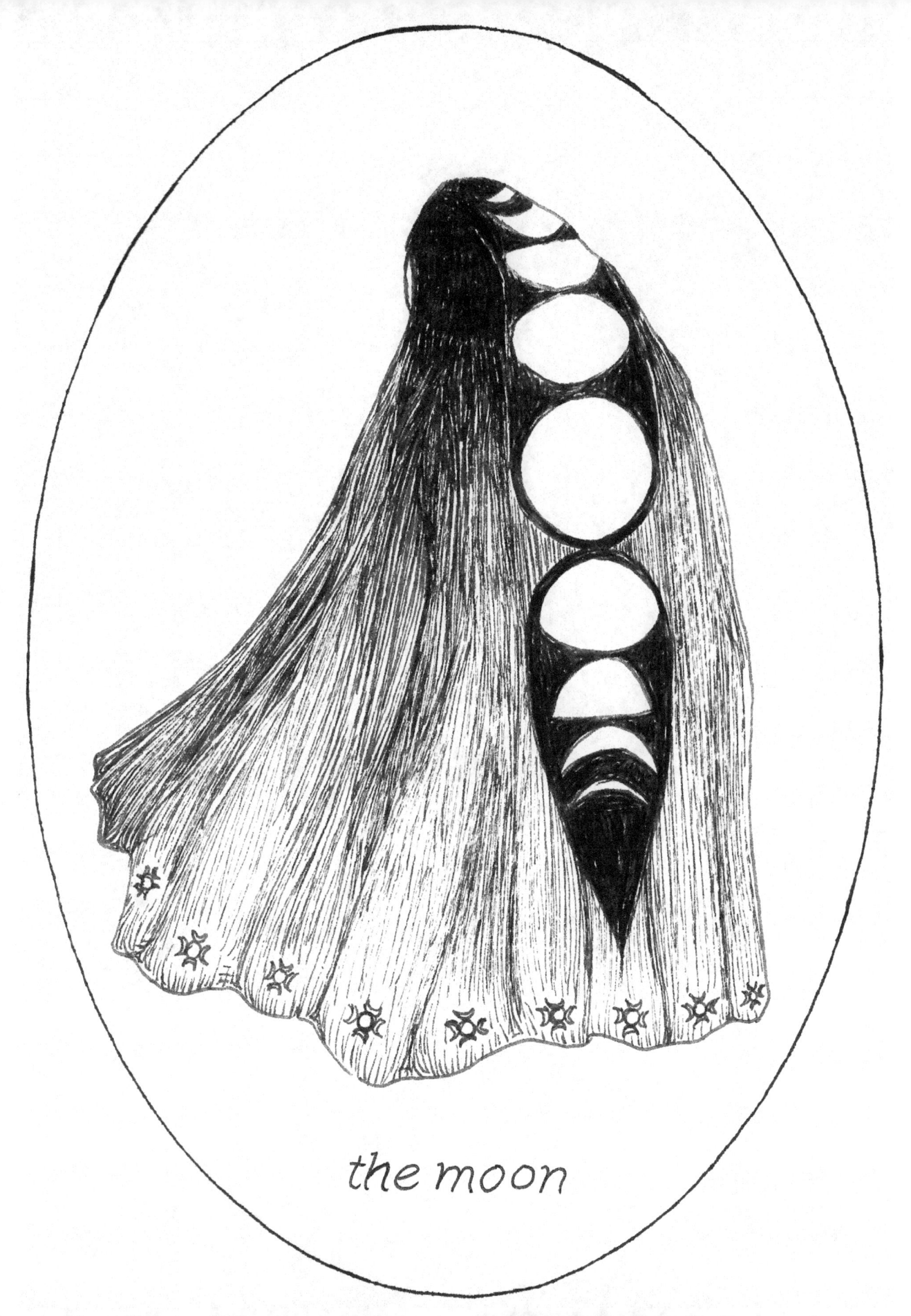

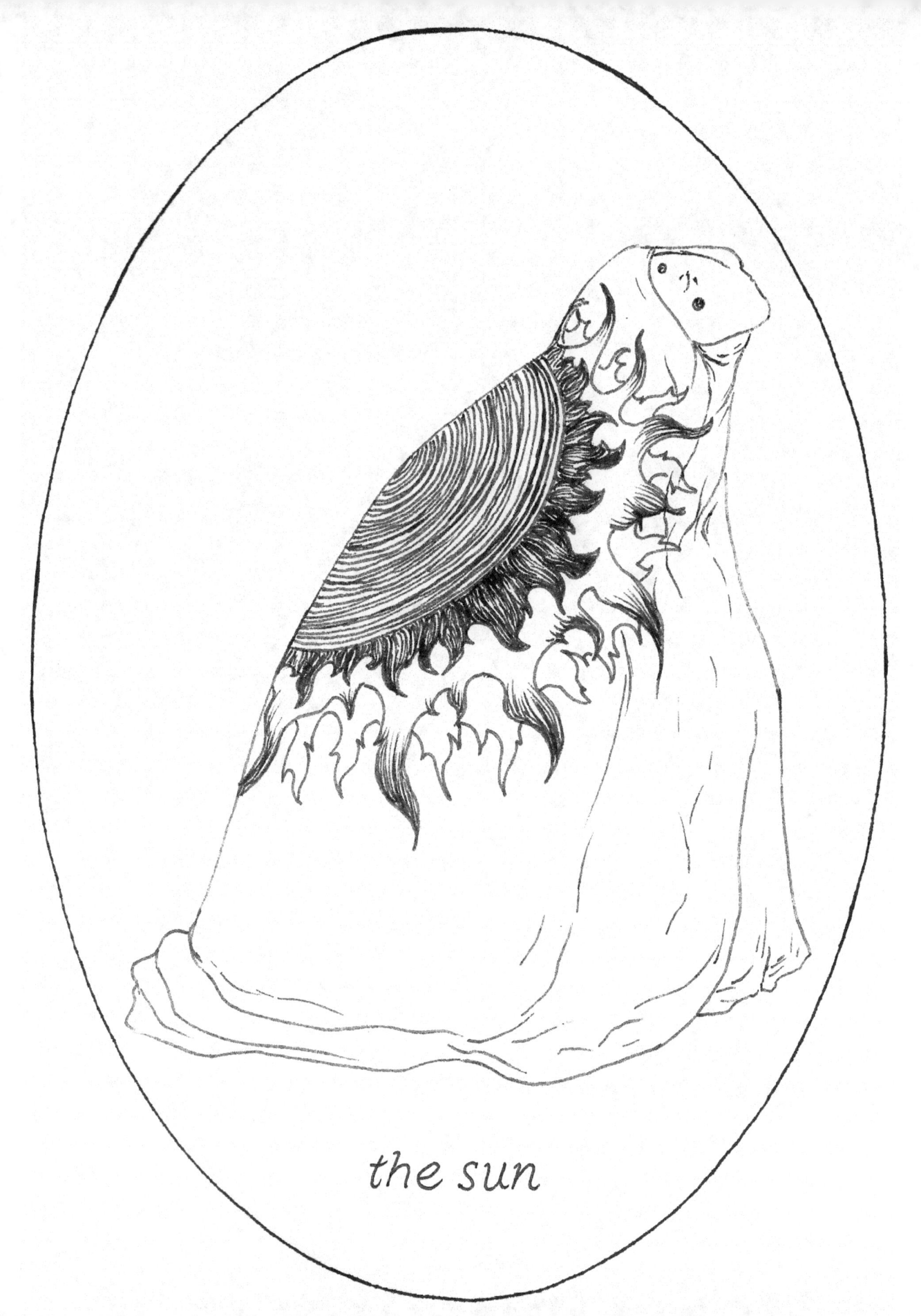

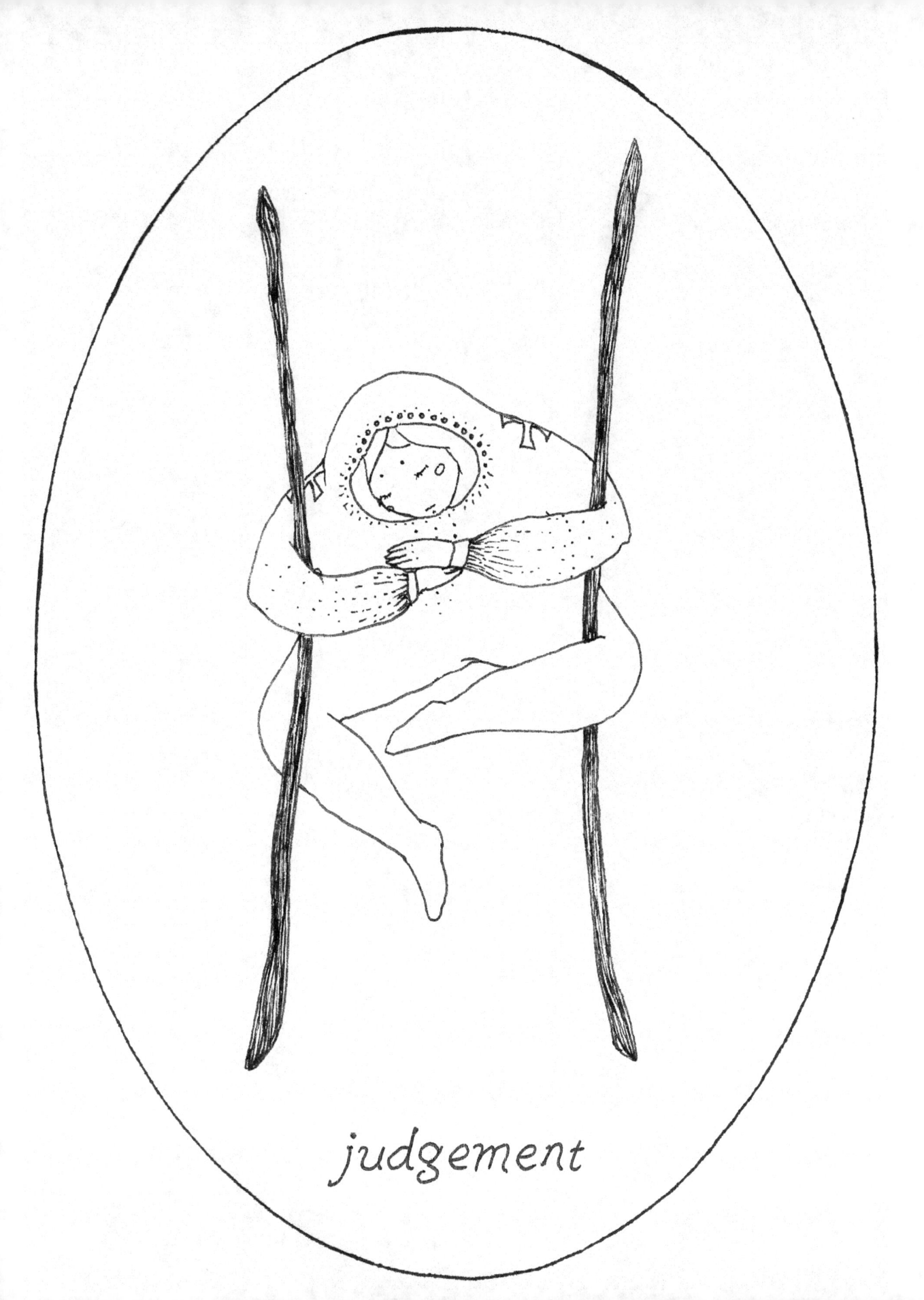

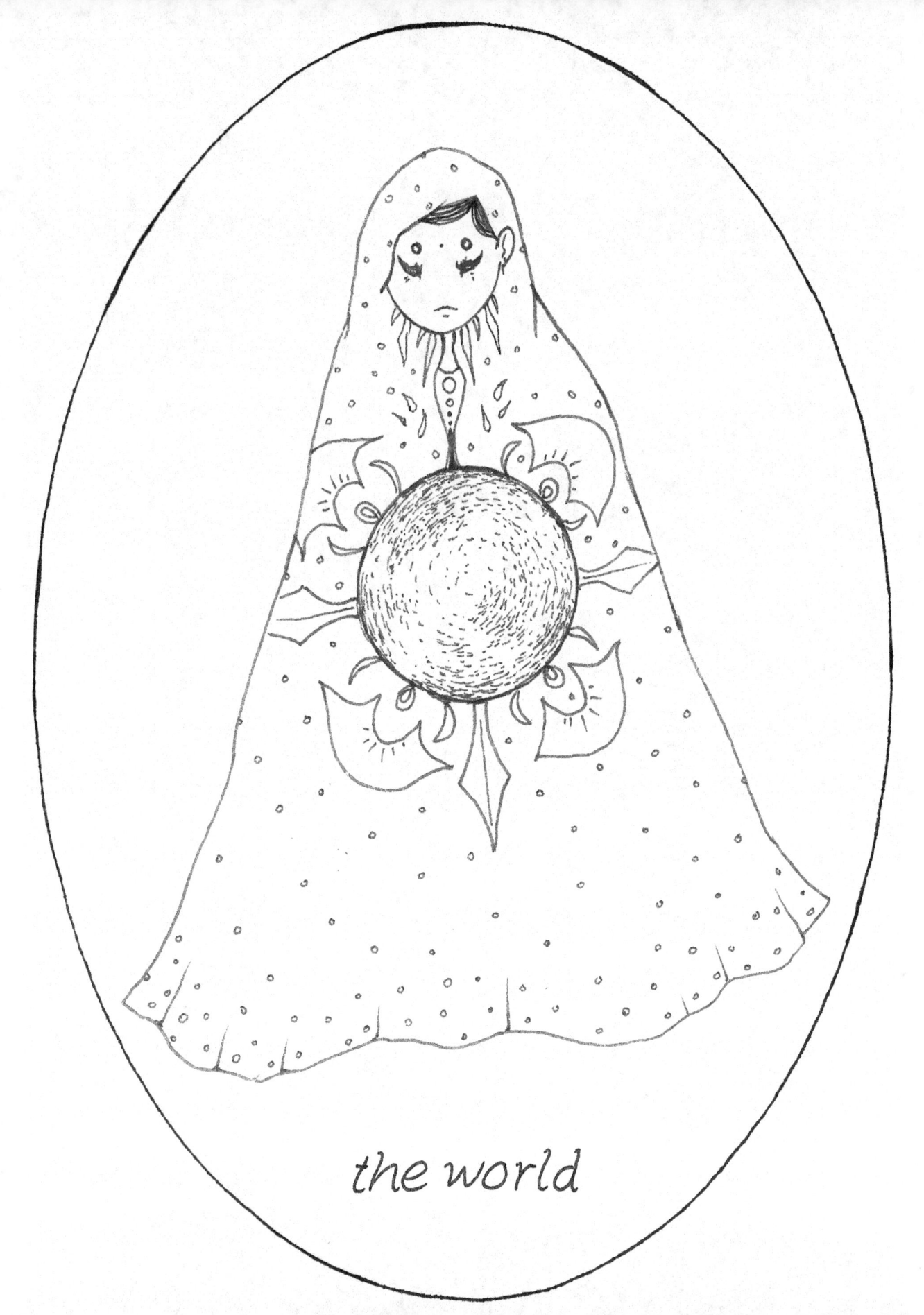

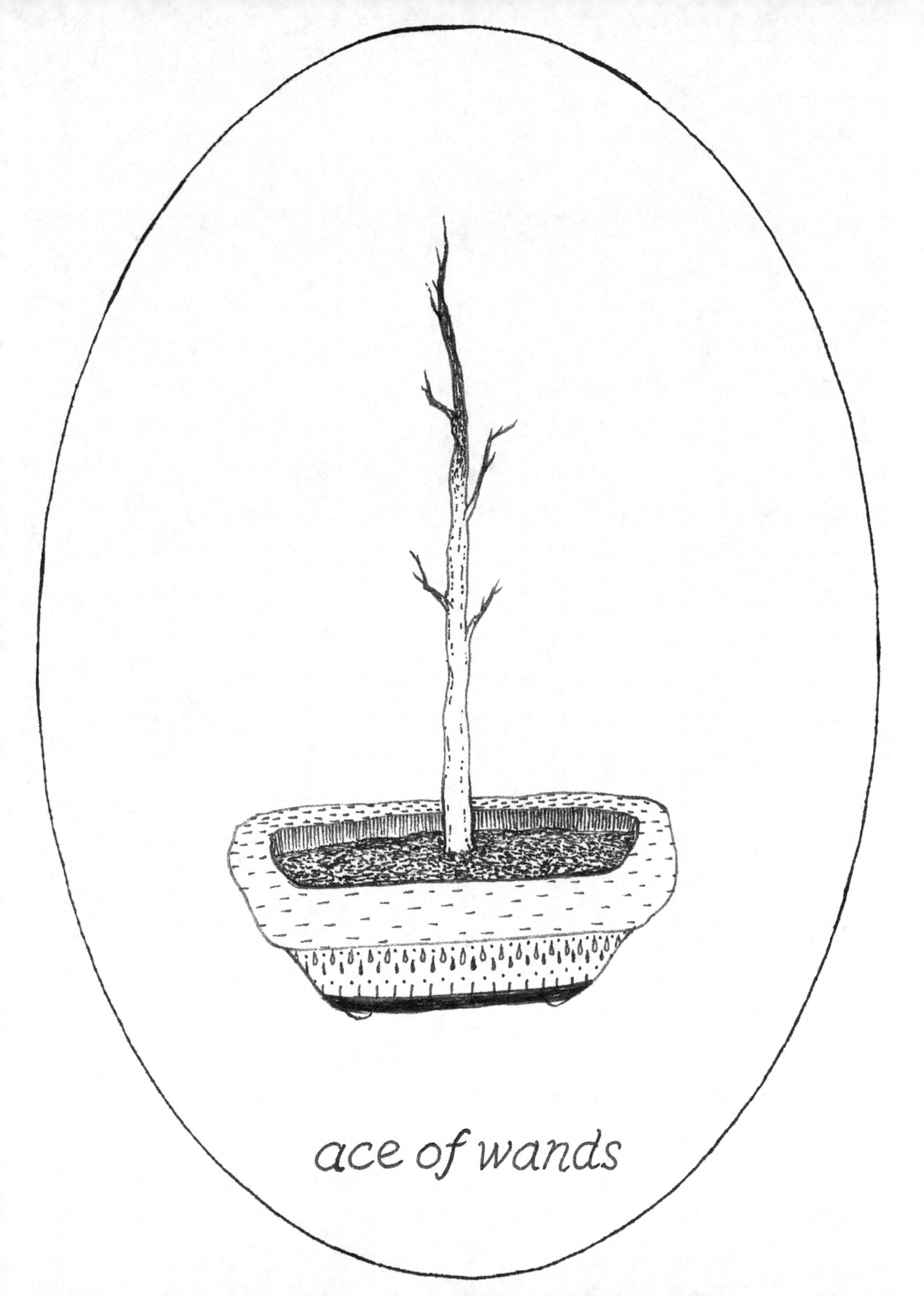

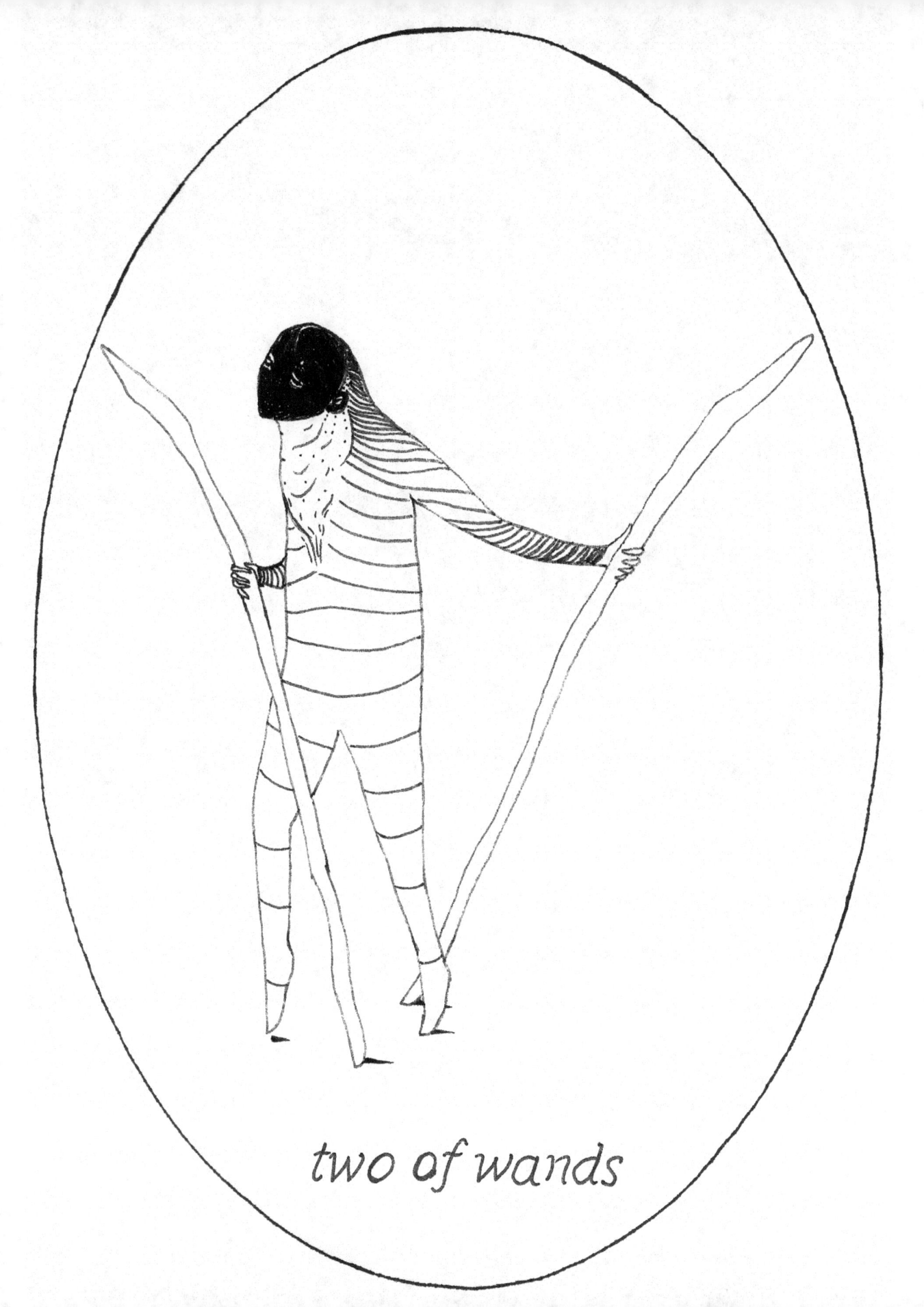

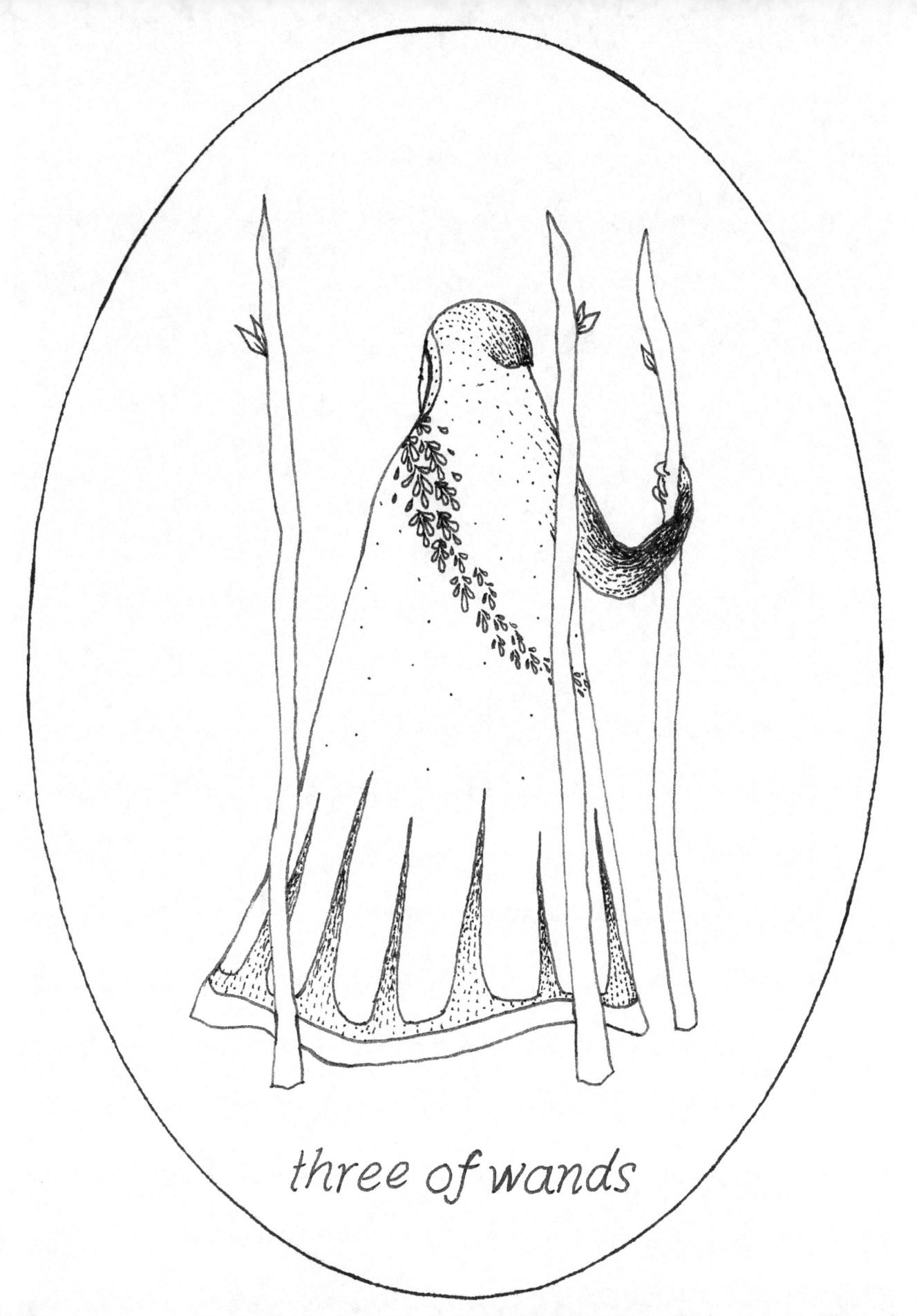

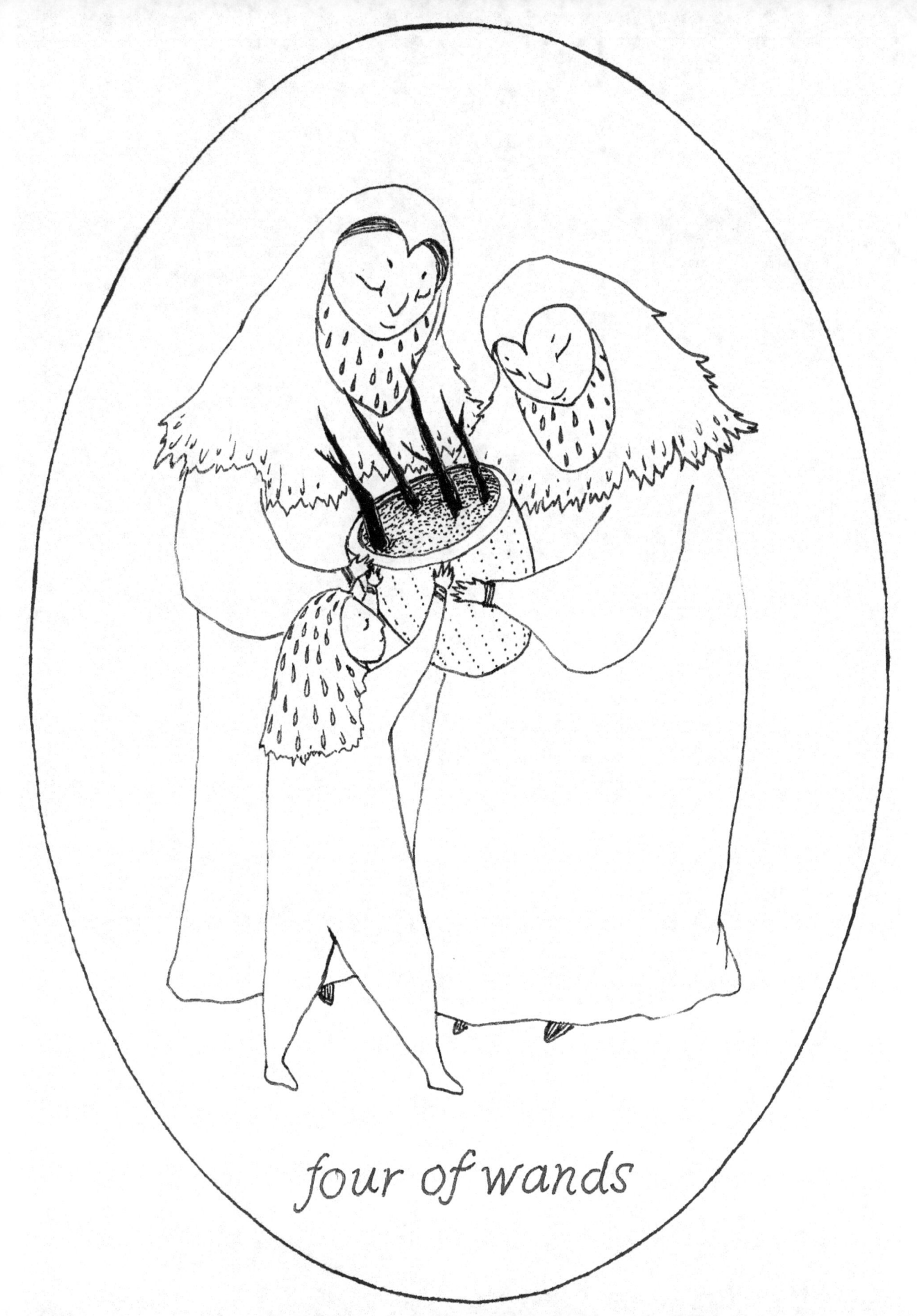

four of wands

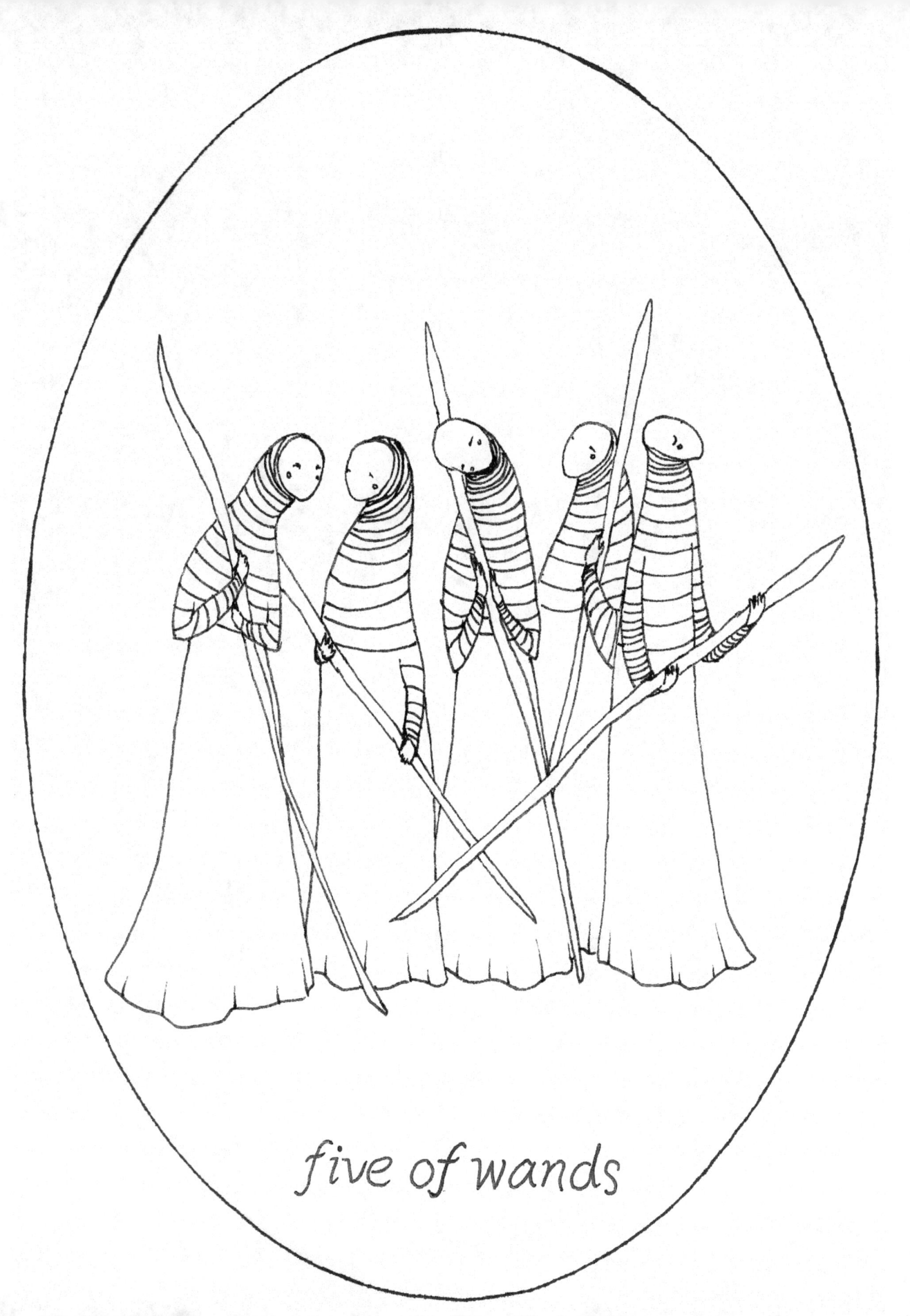

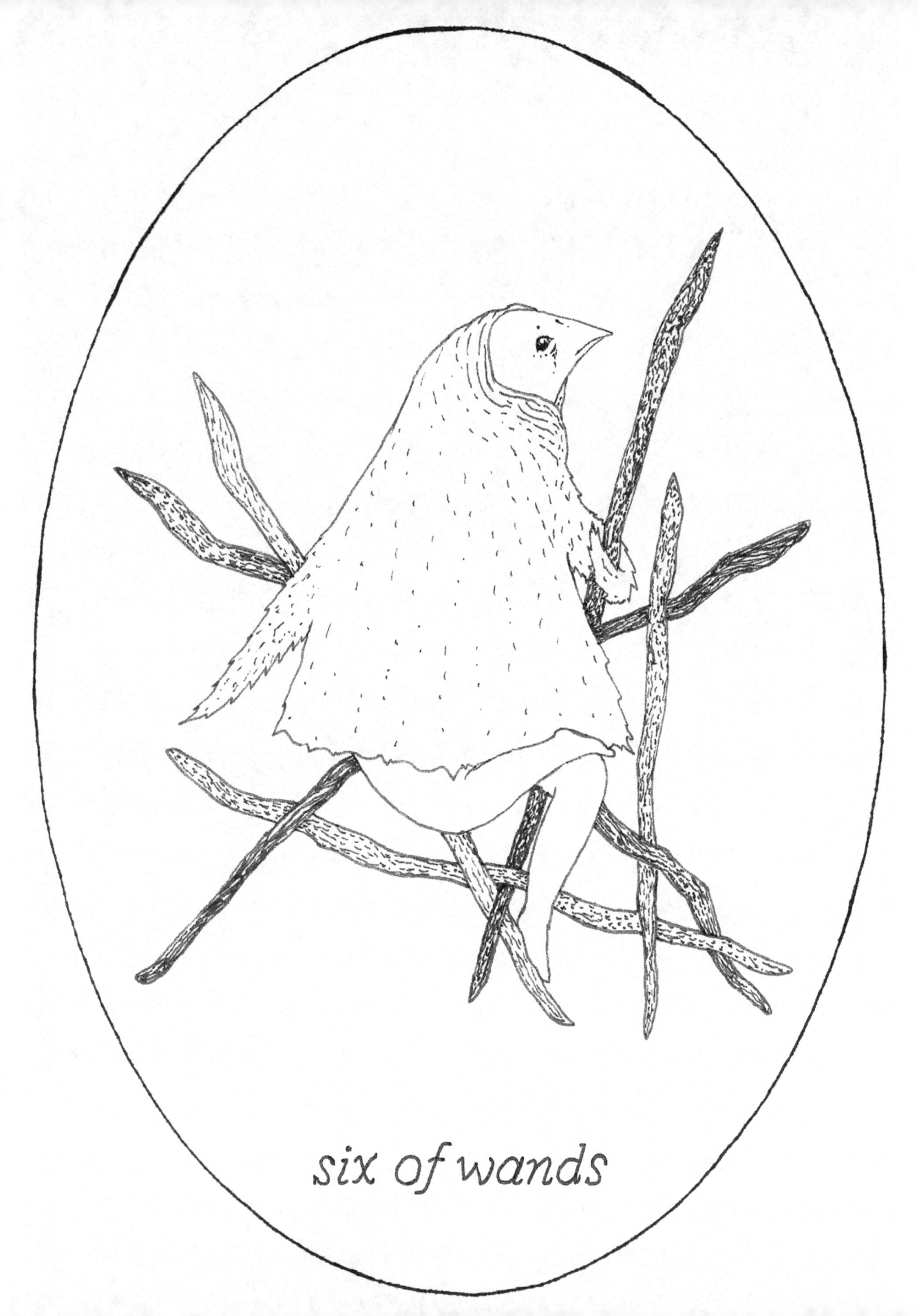

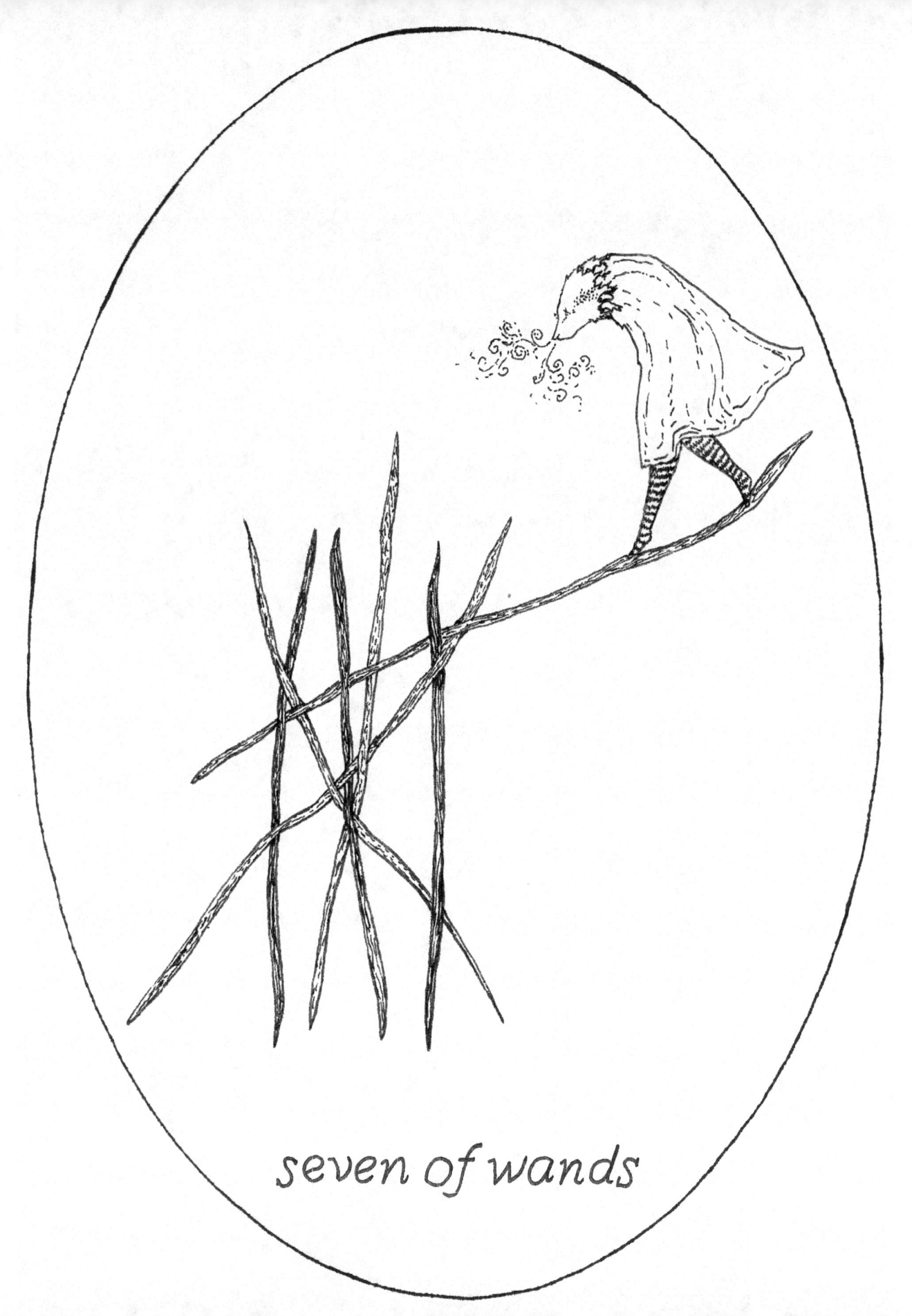

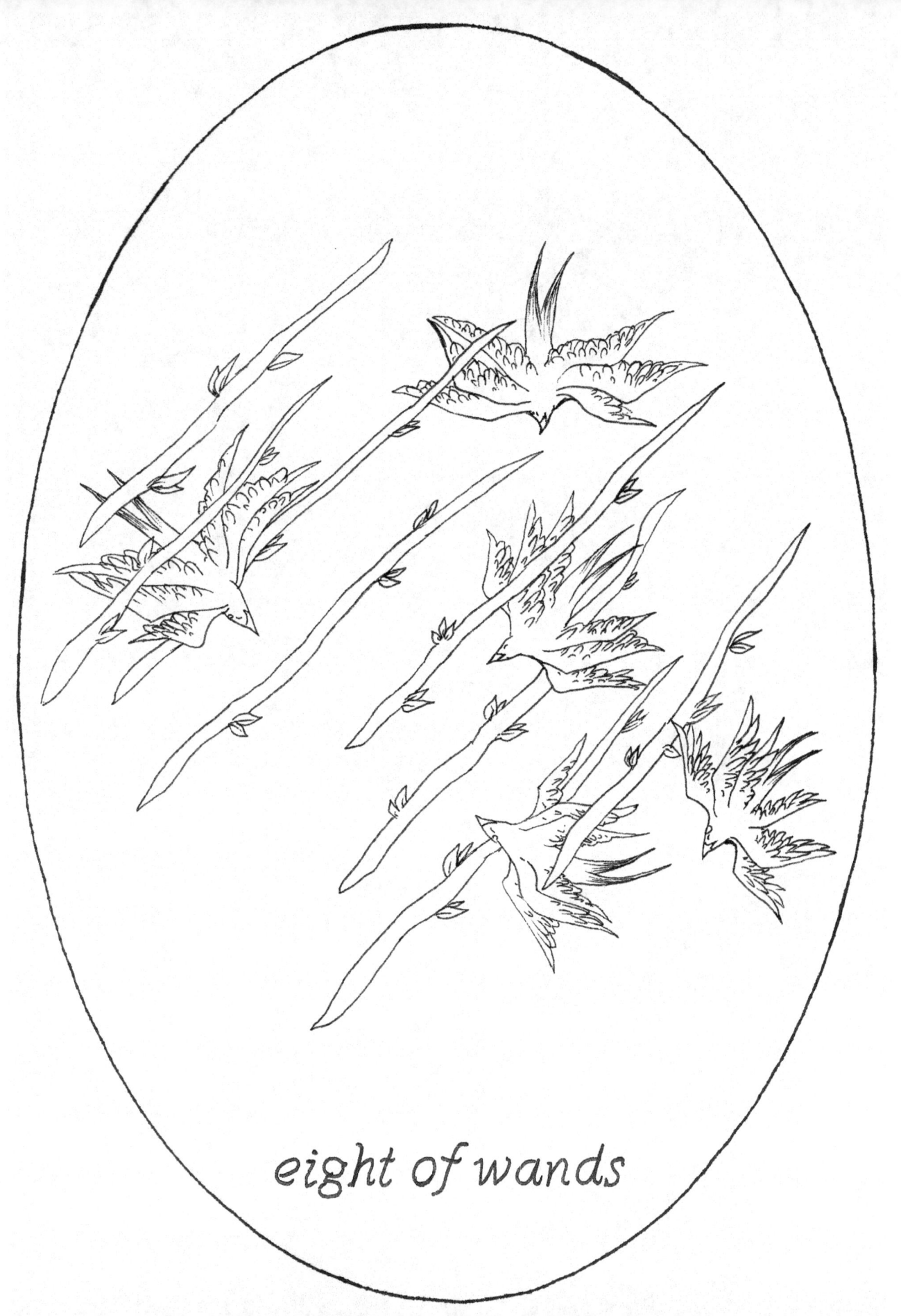

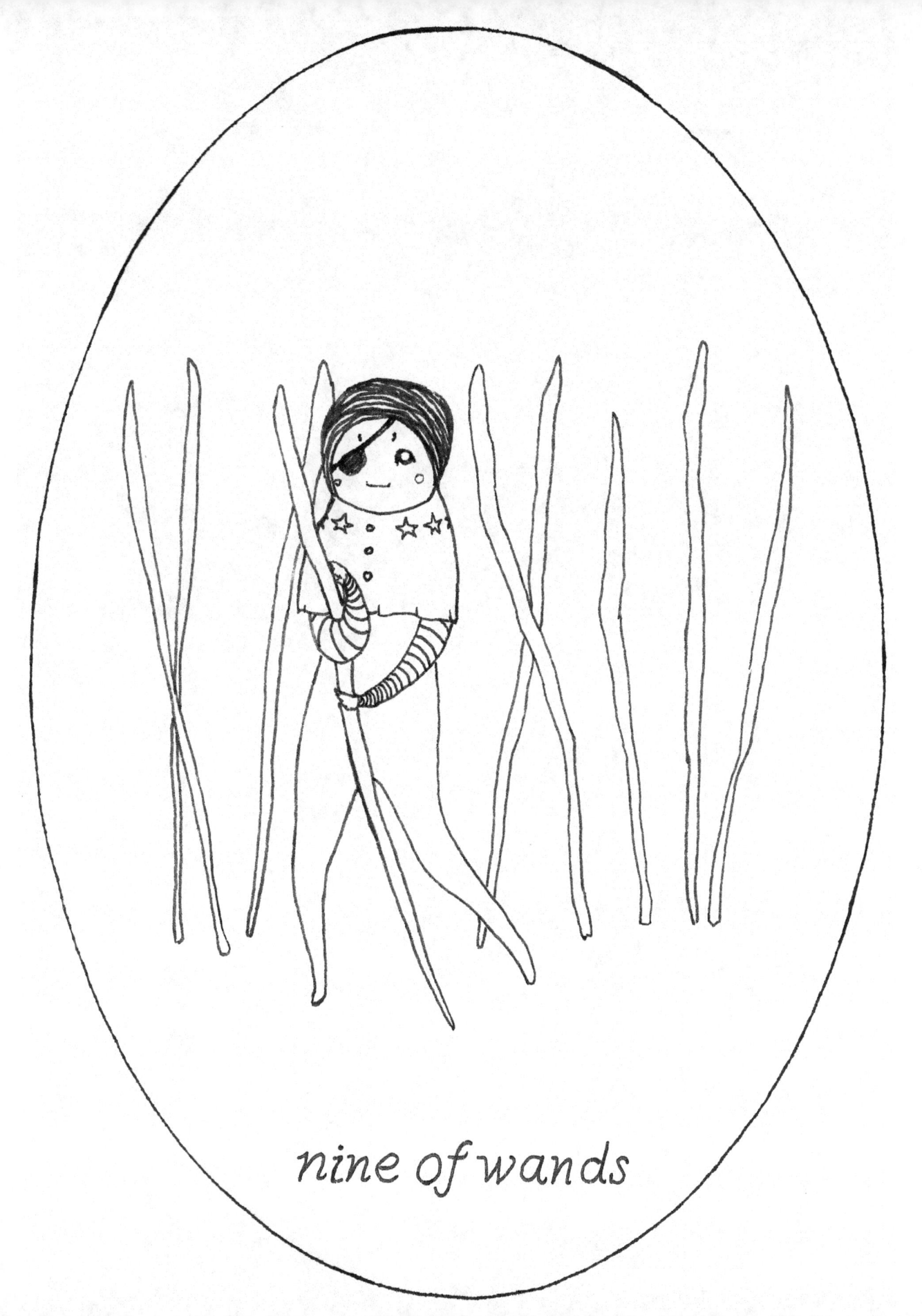

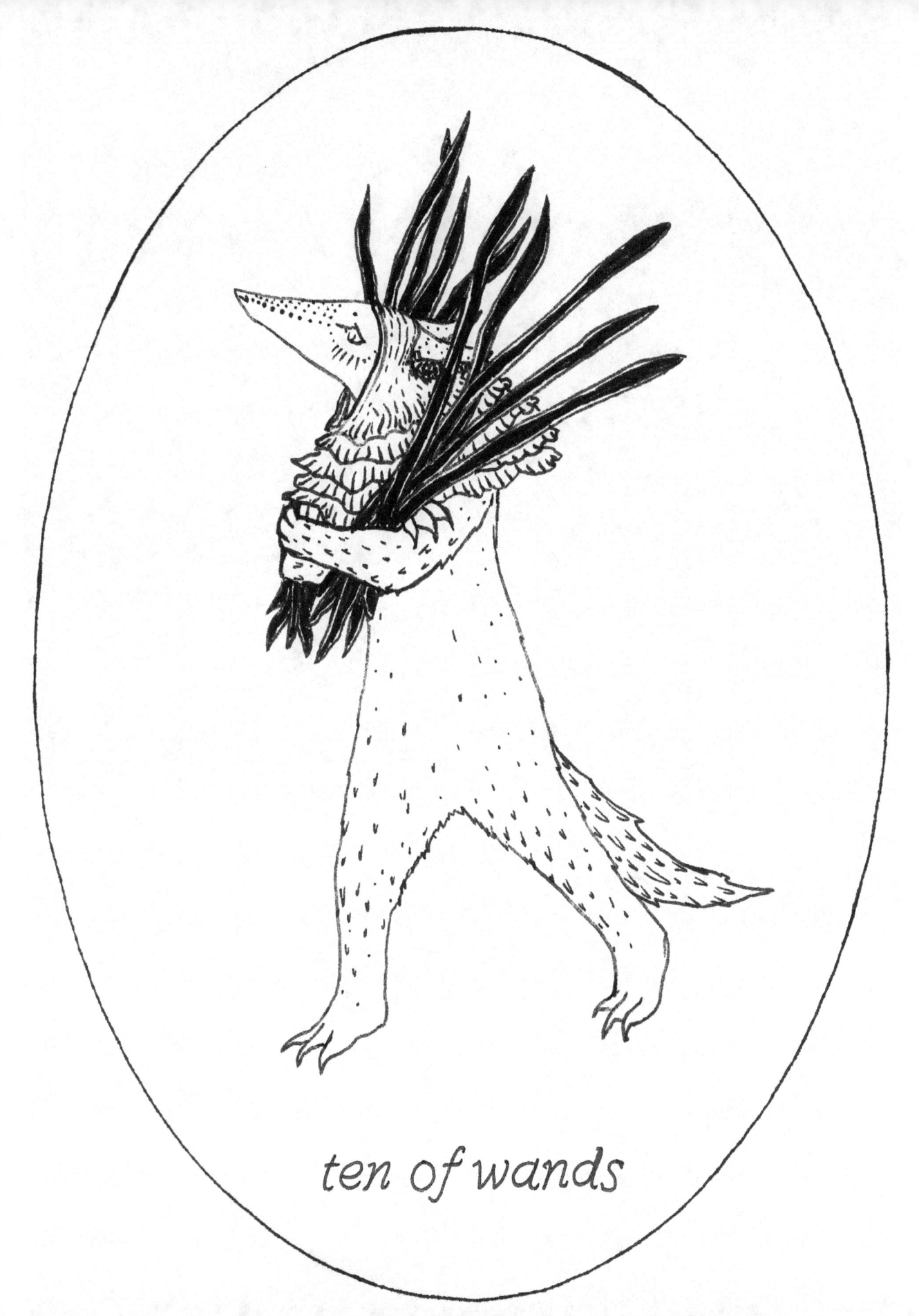

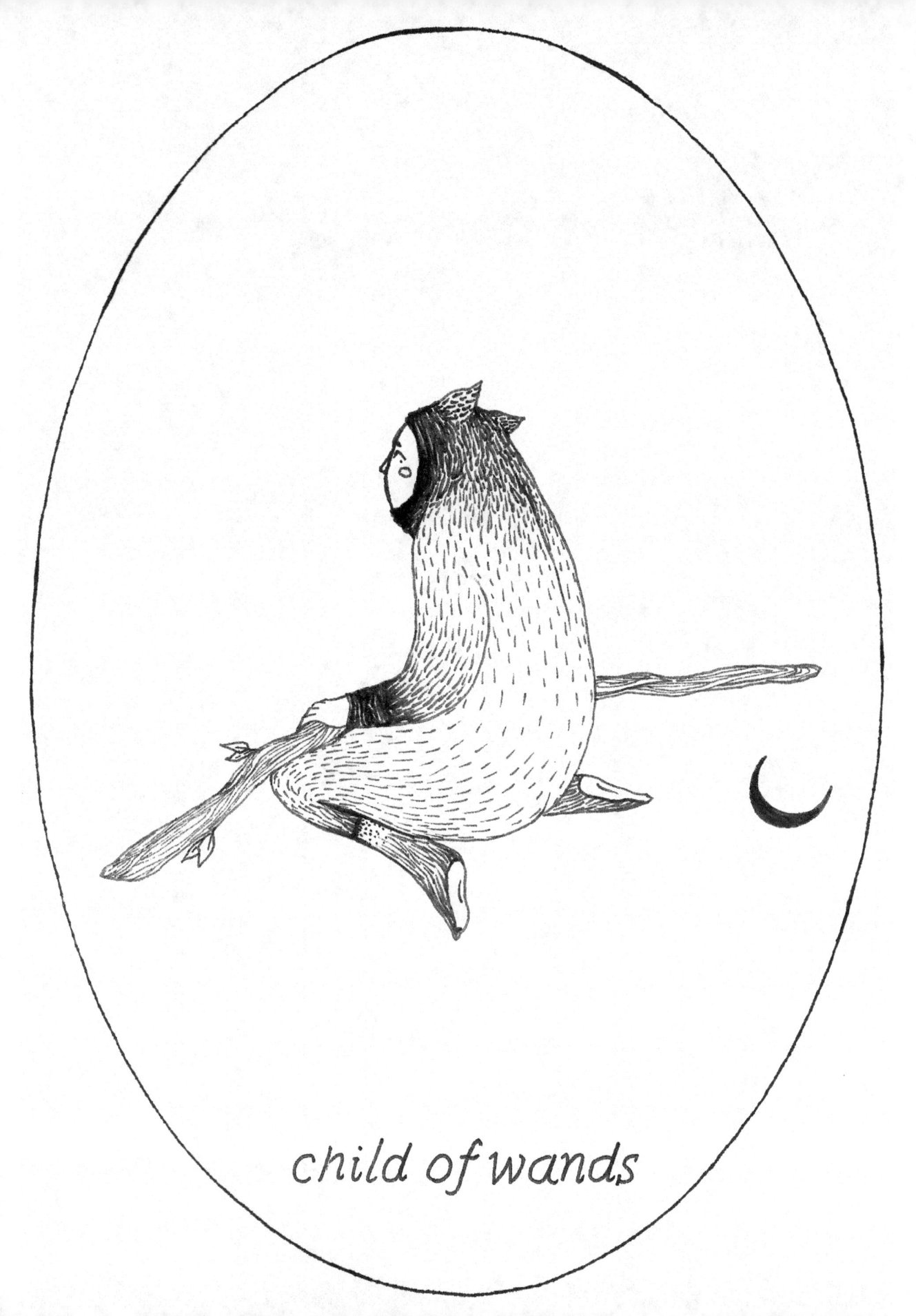

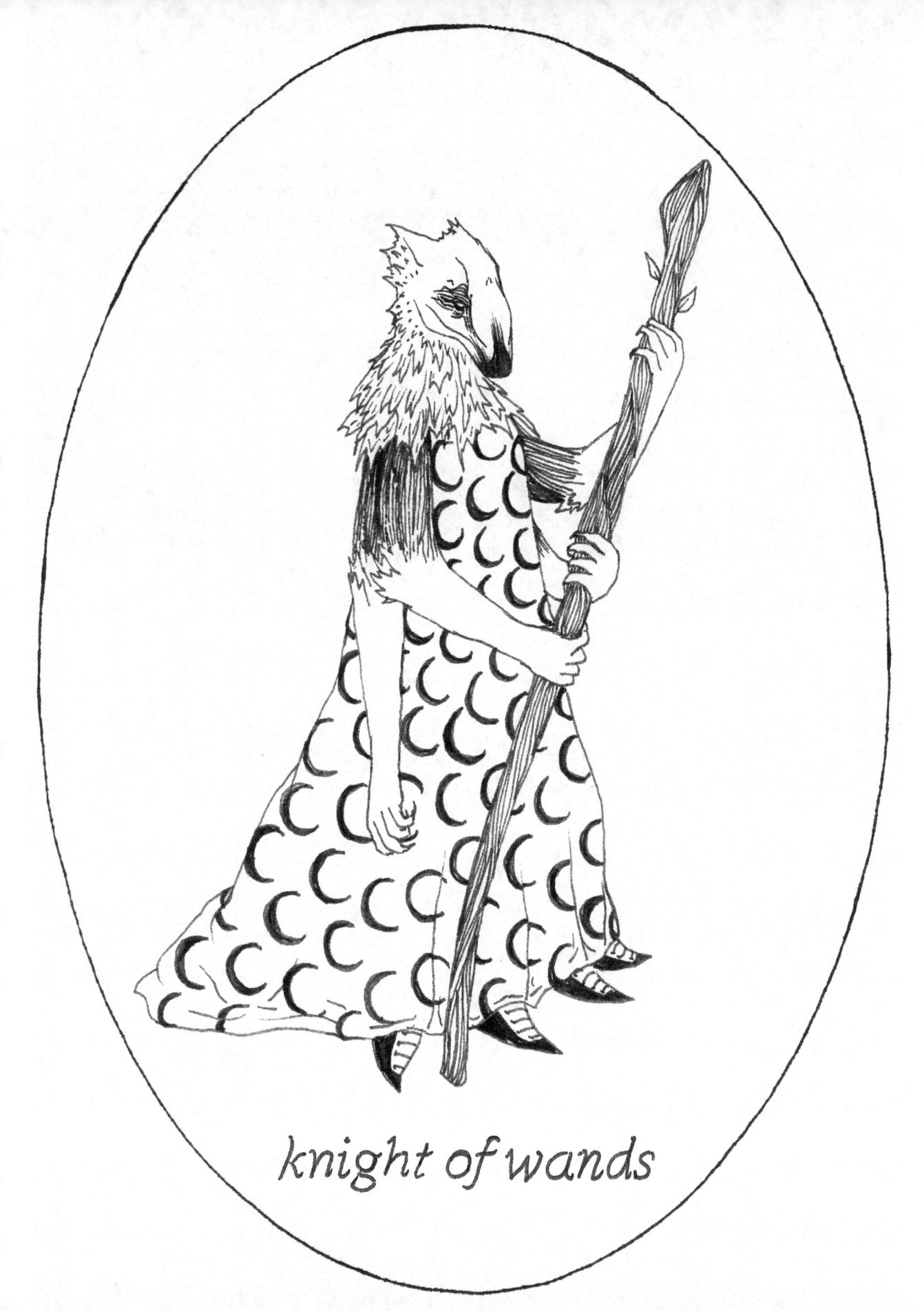

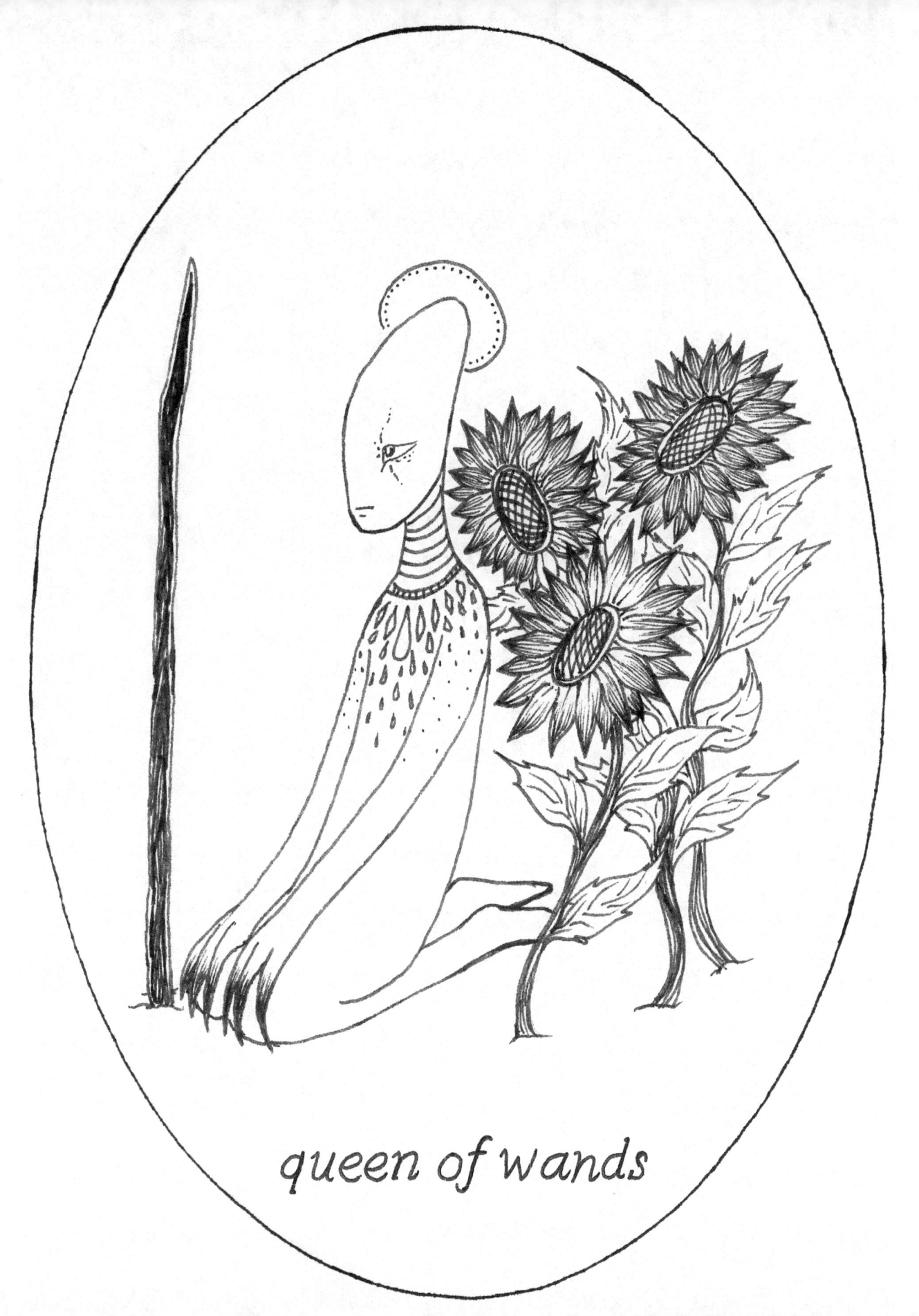

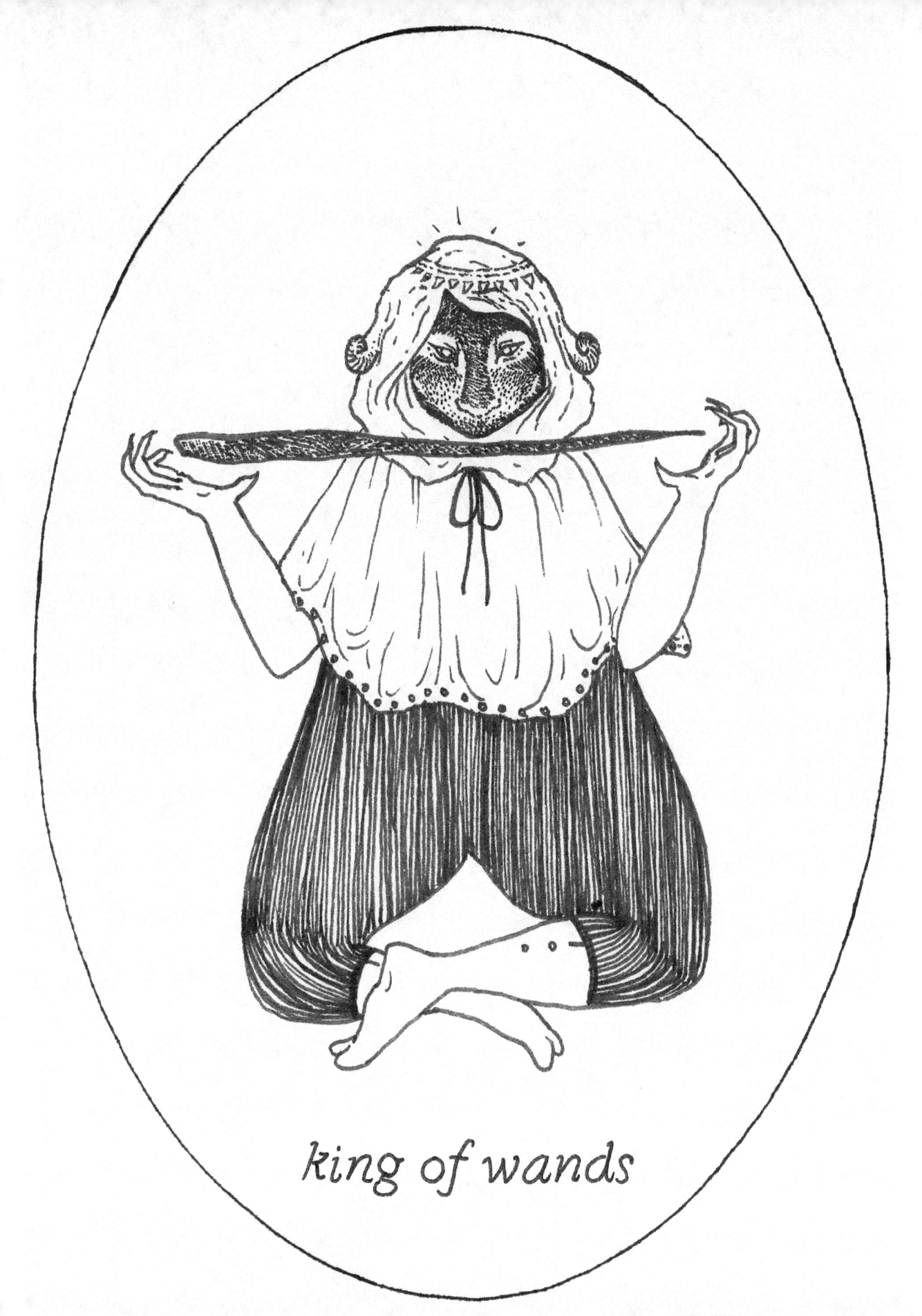

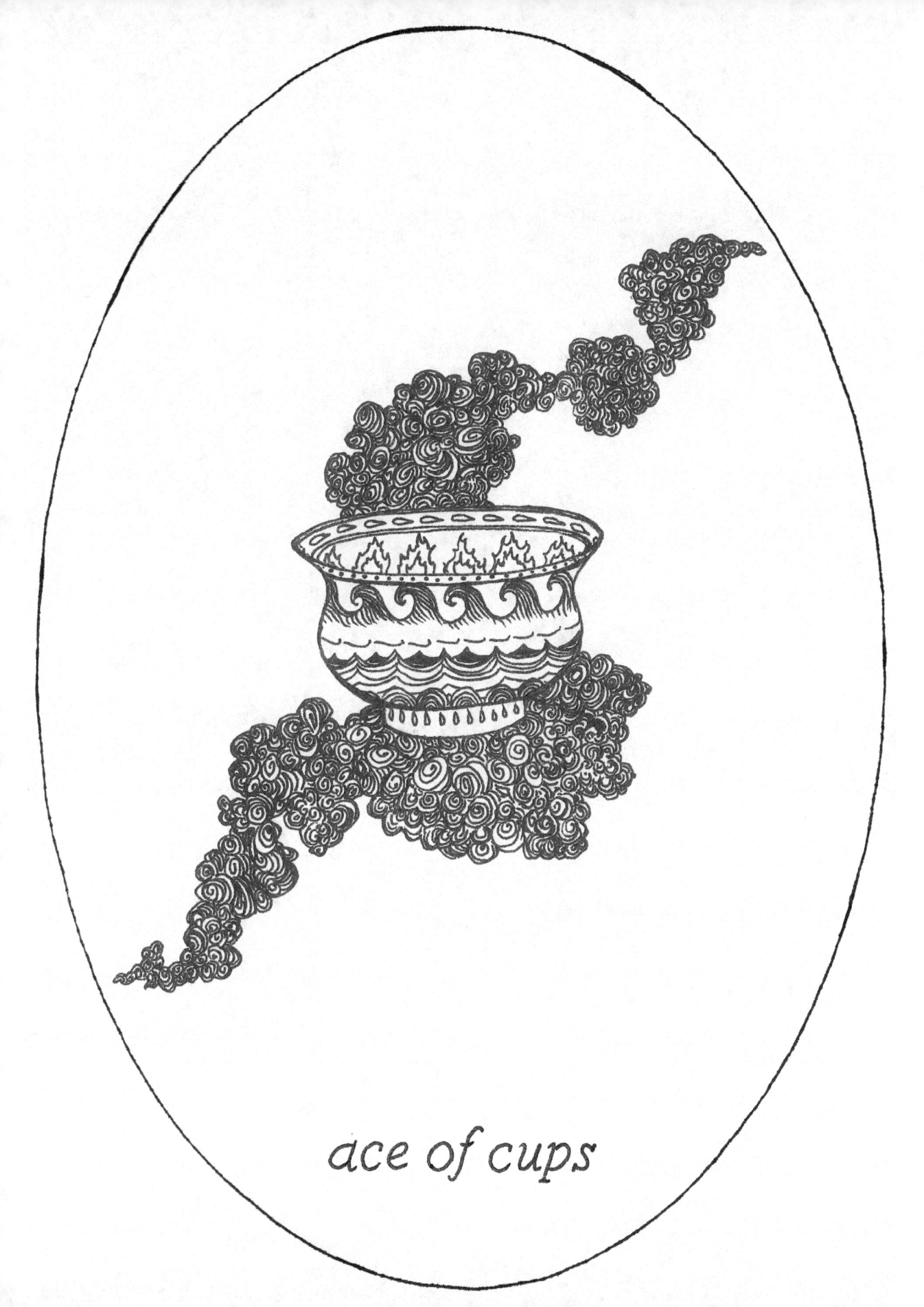

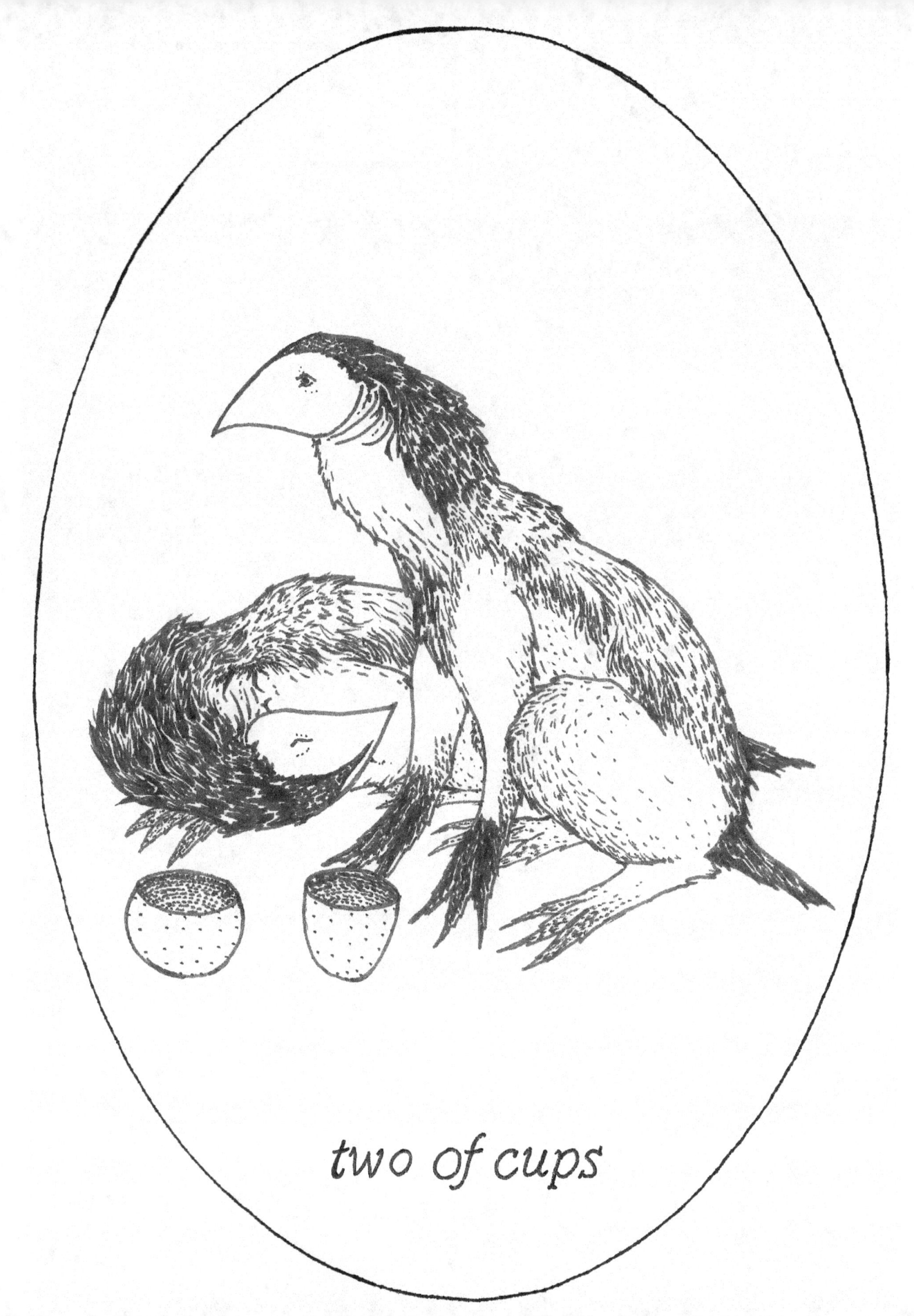

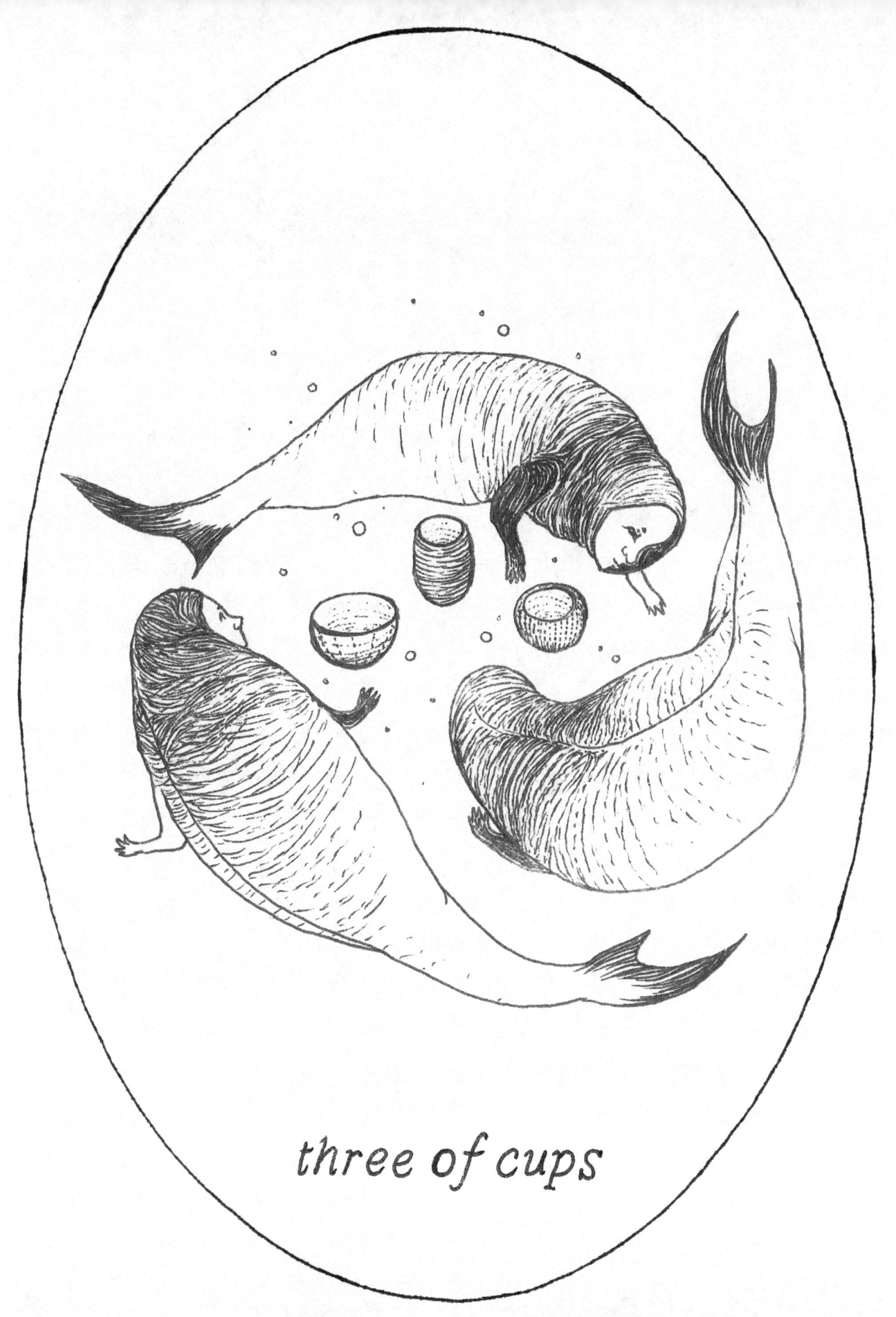

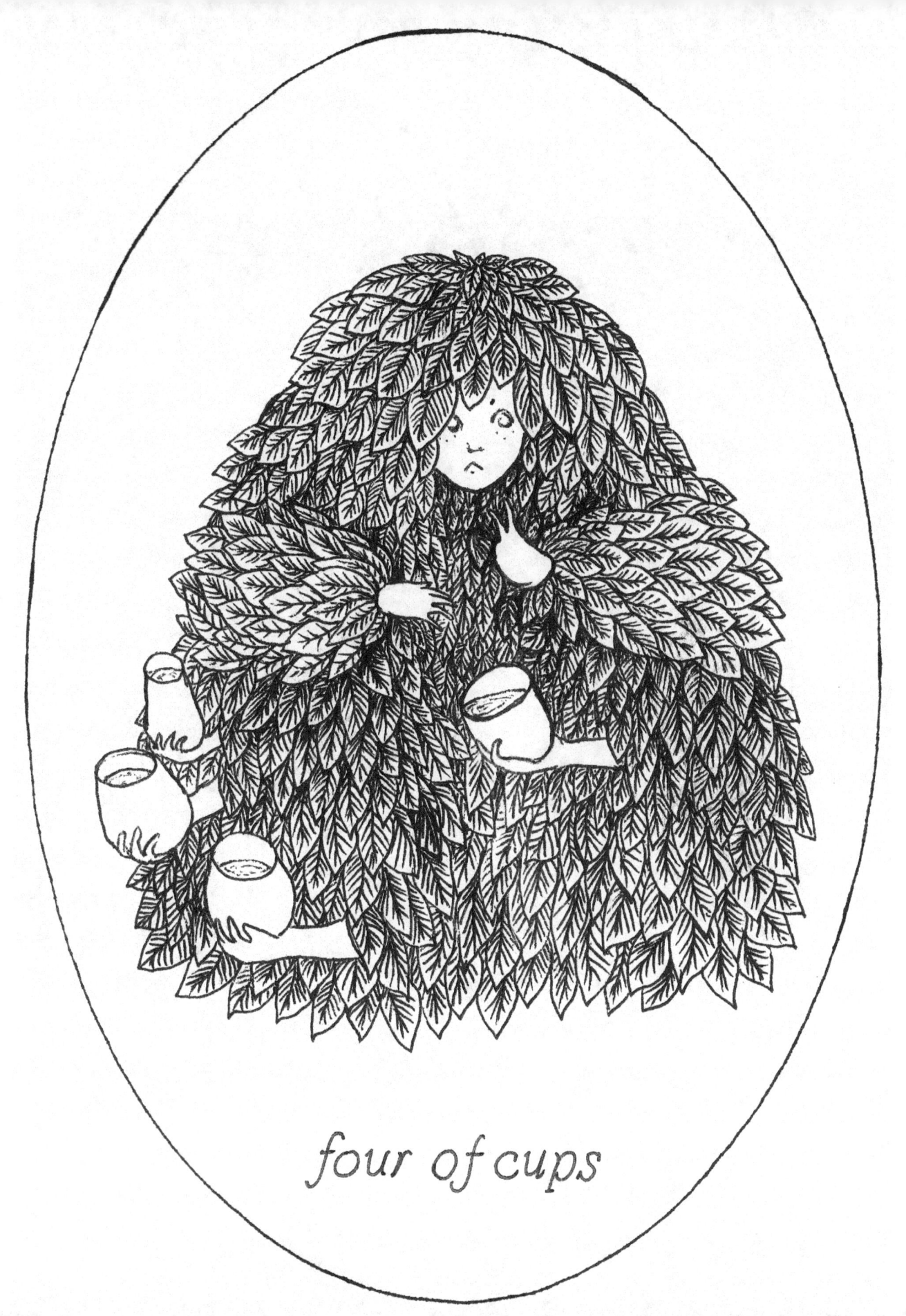

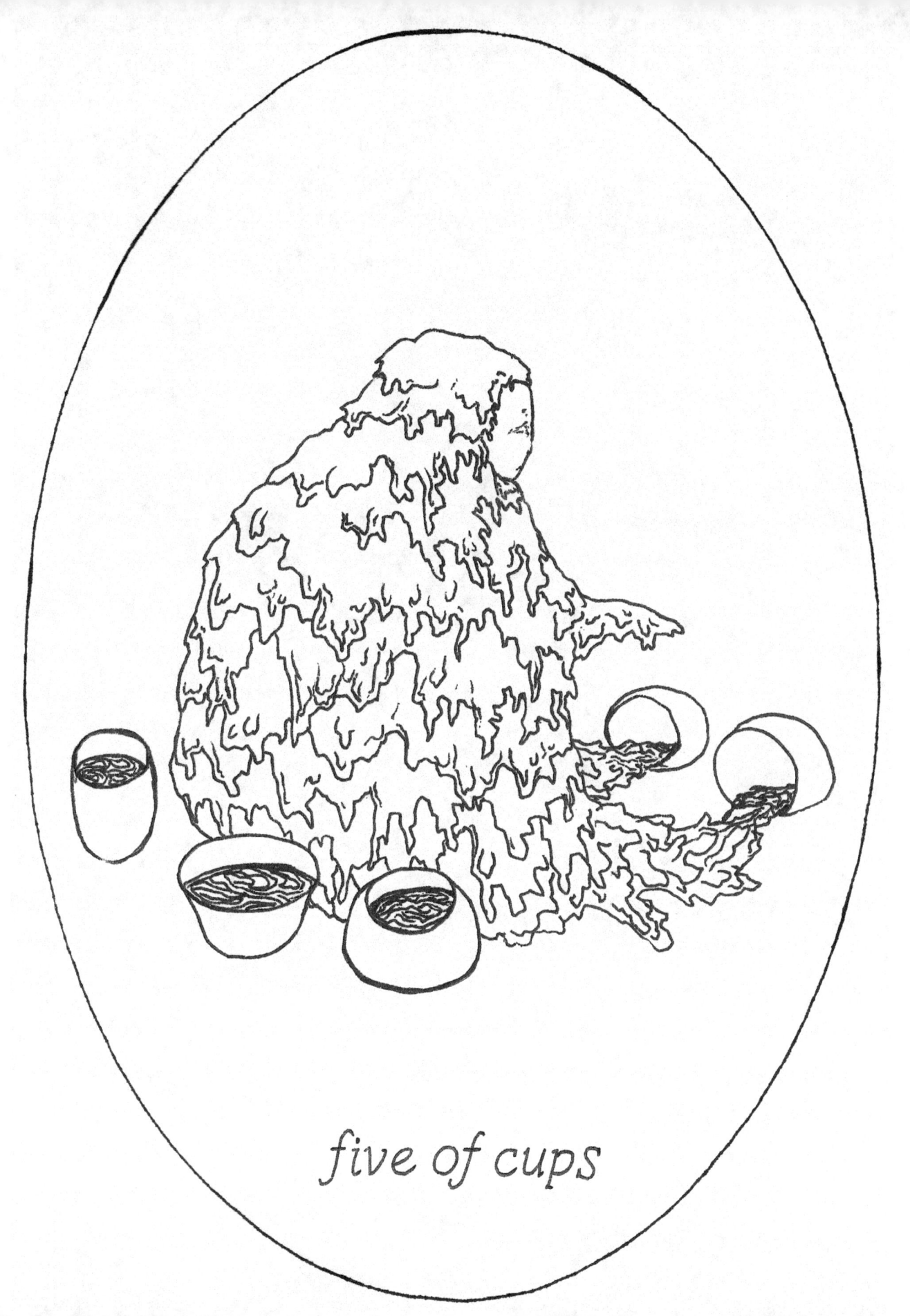

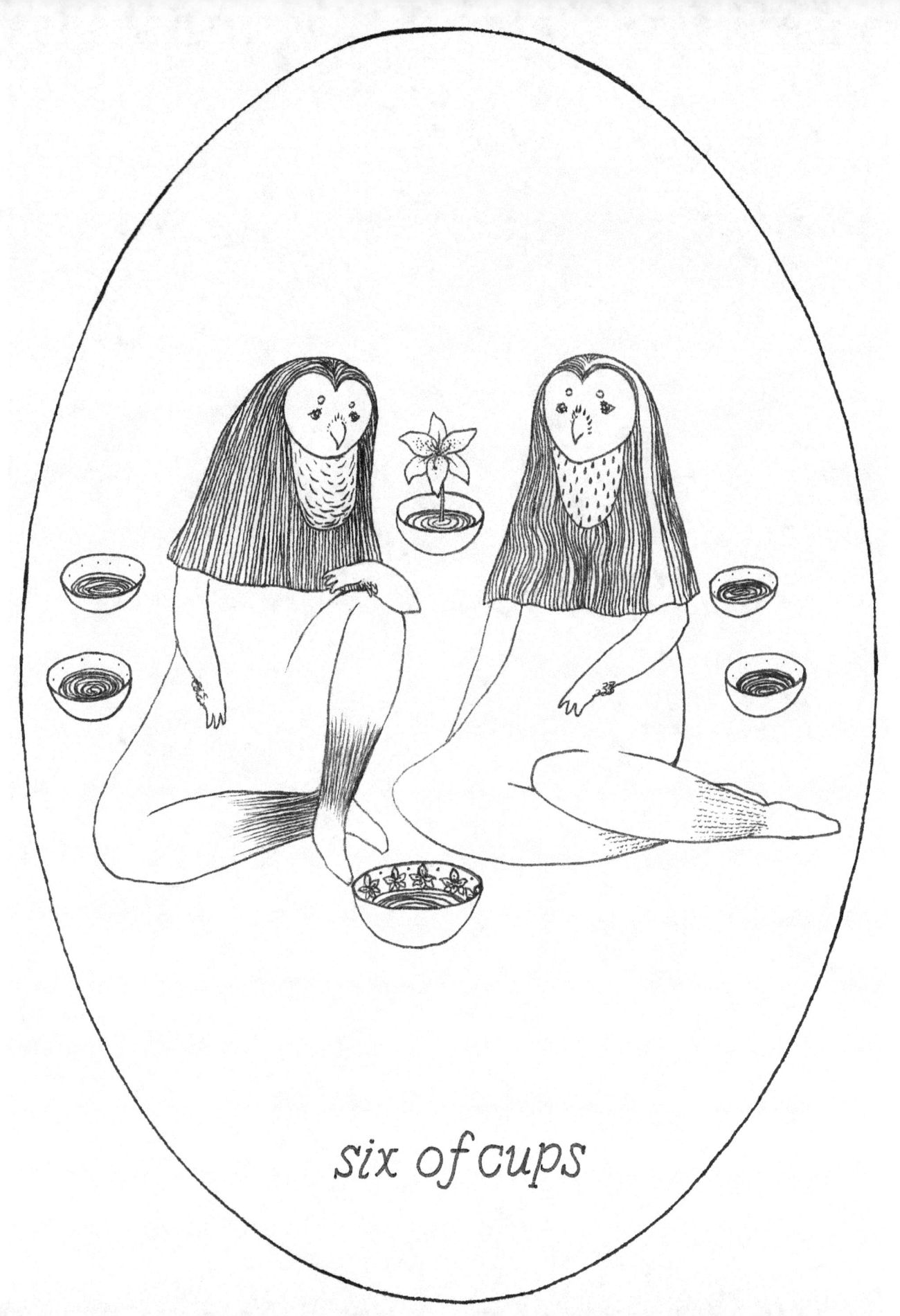

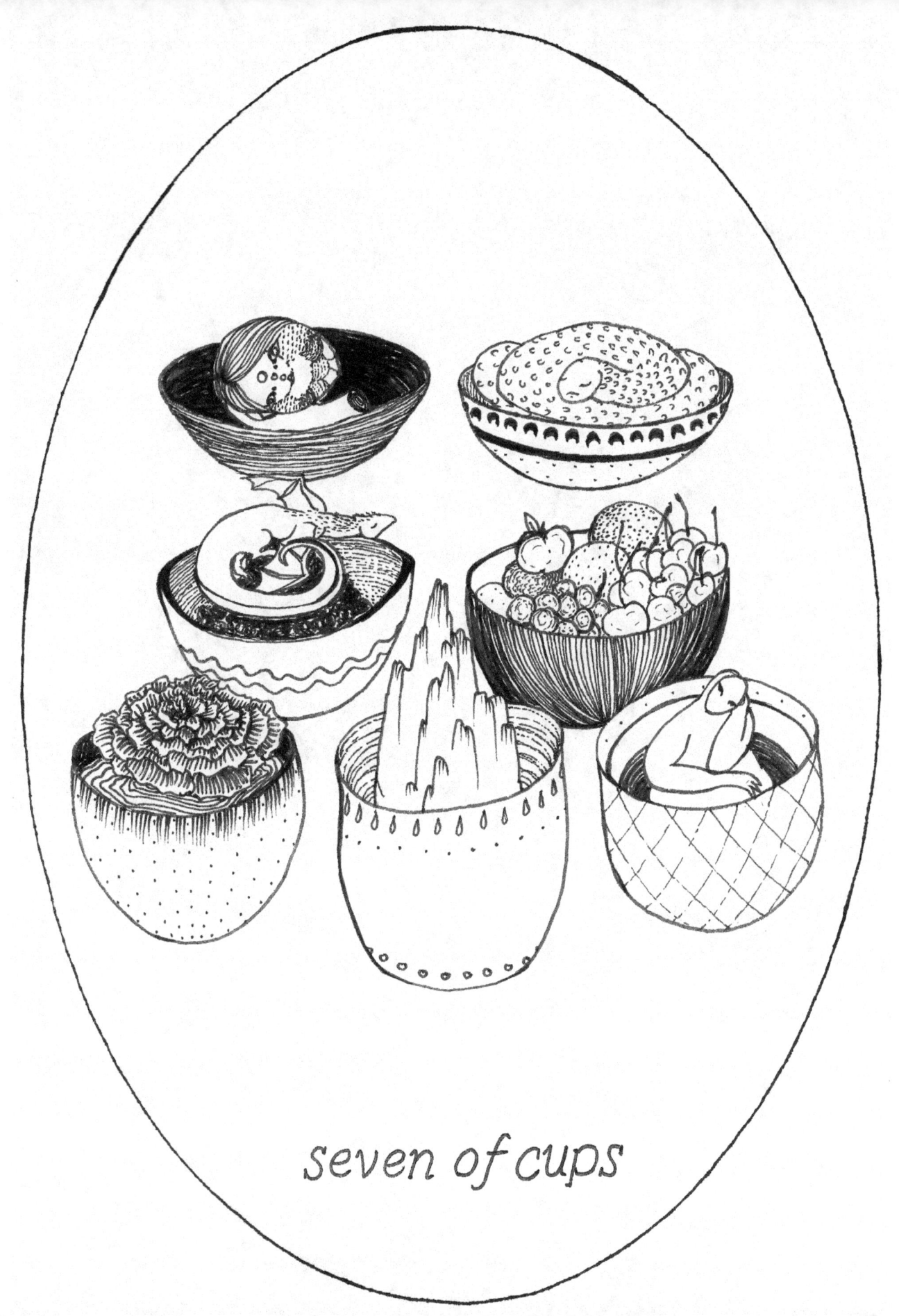

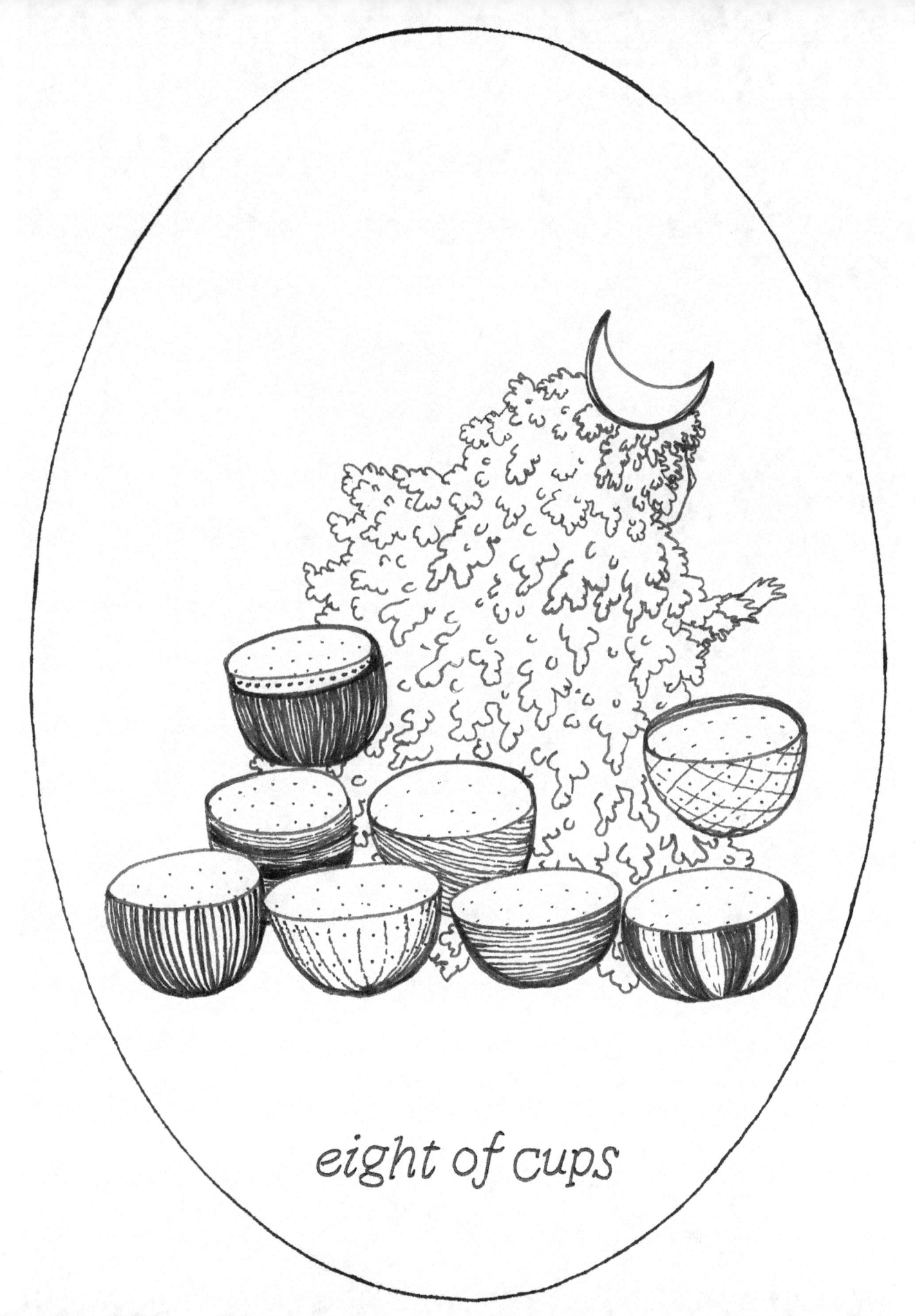

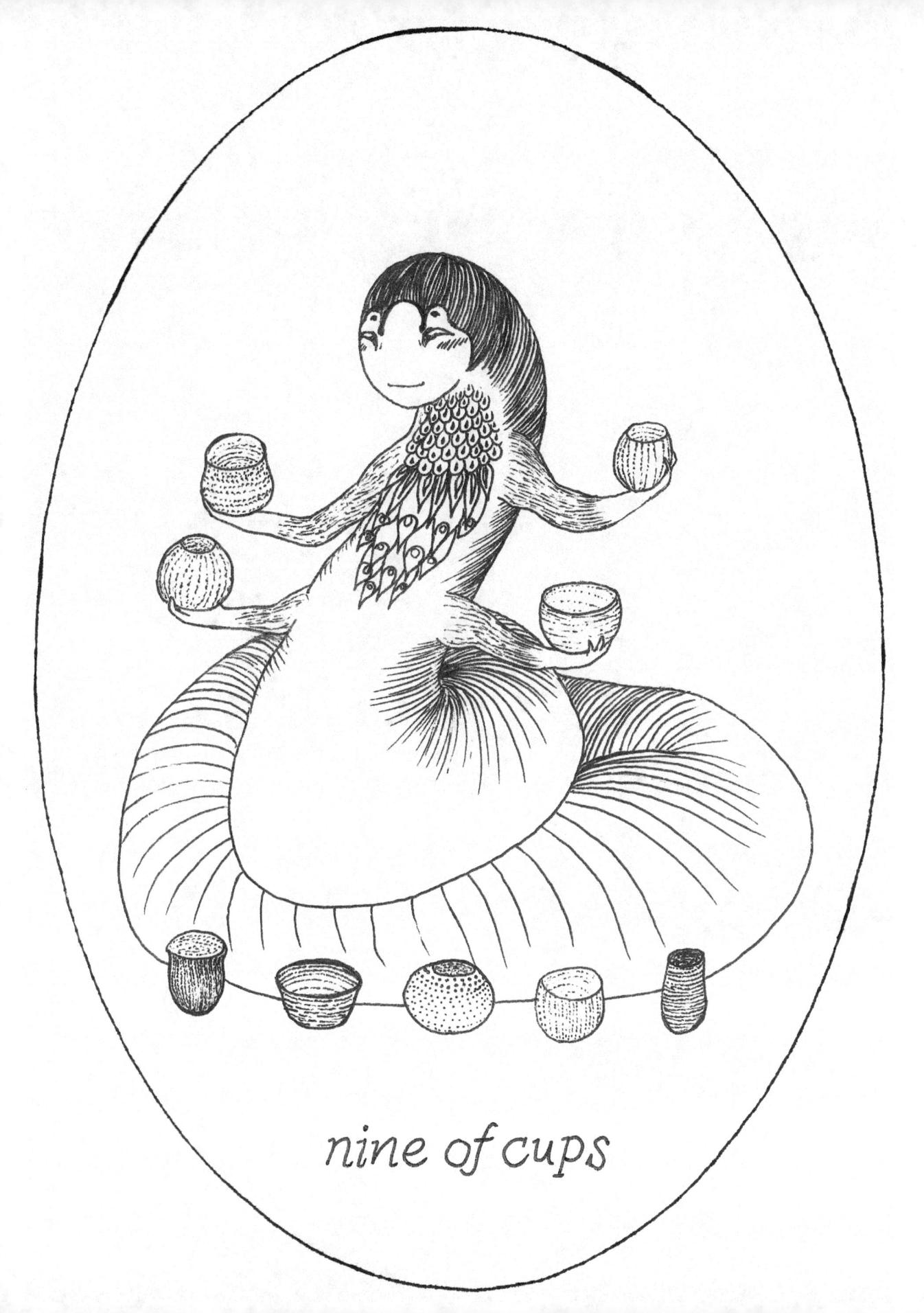

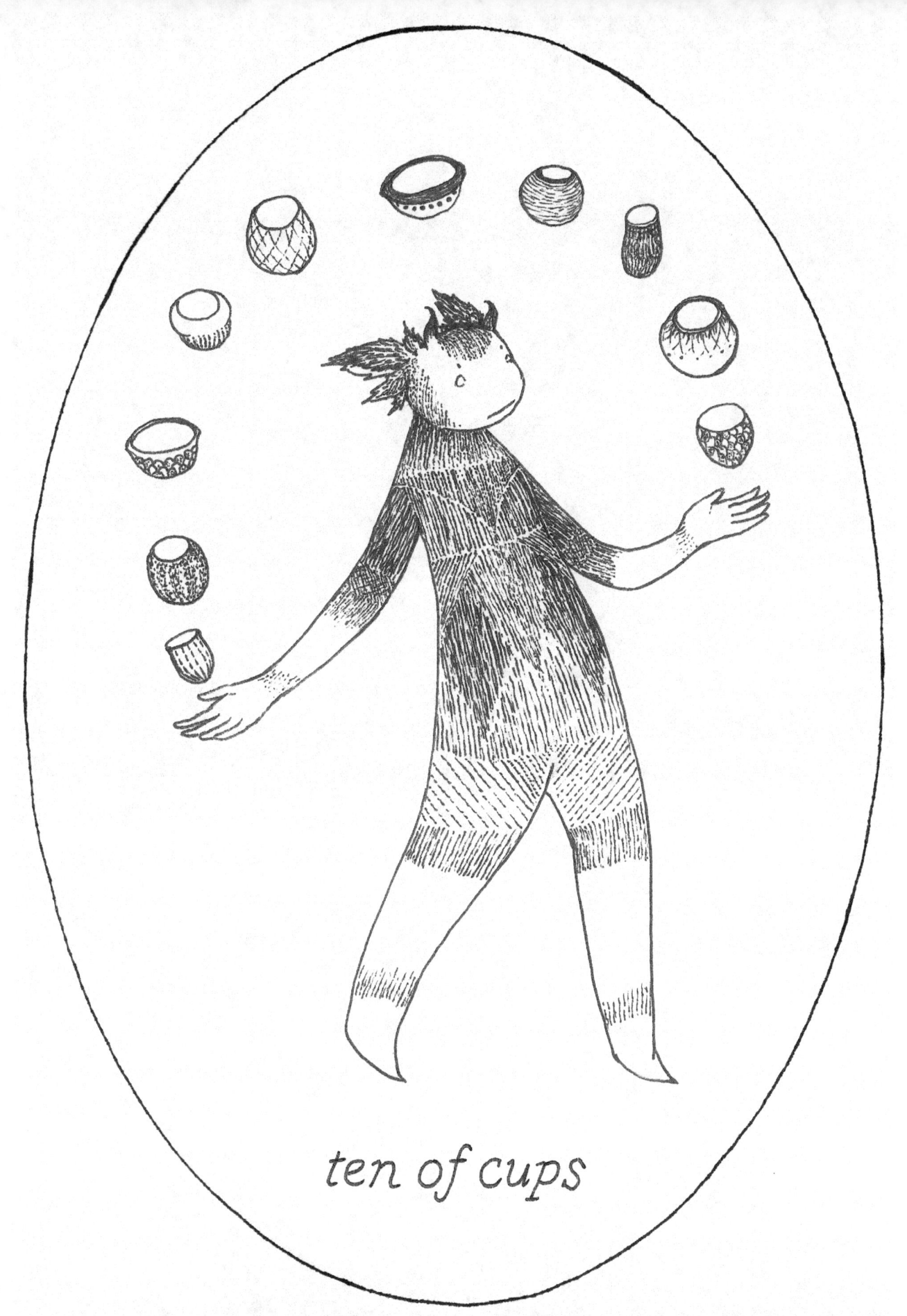

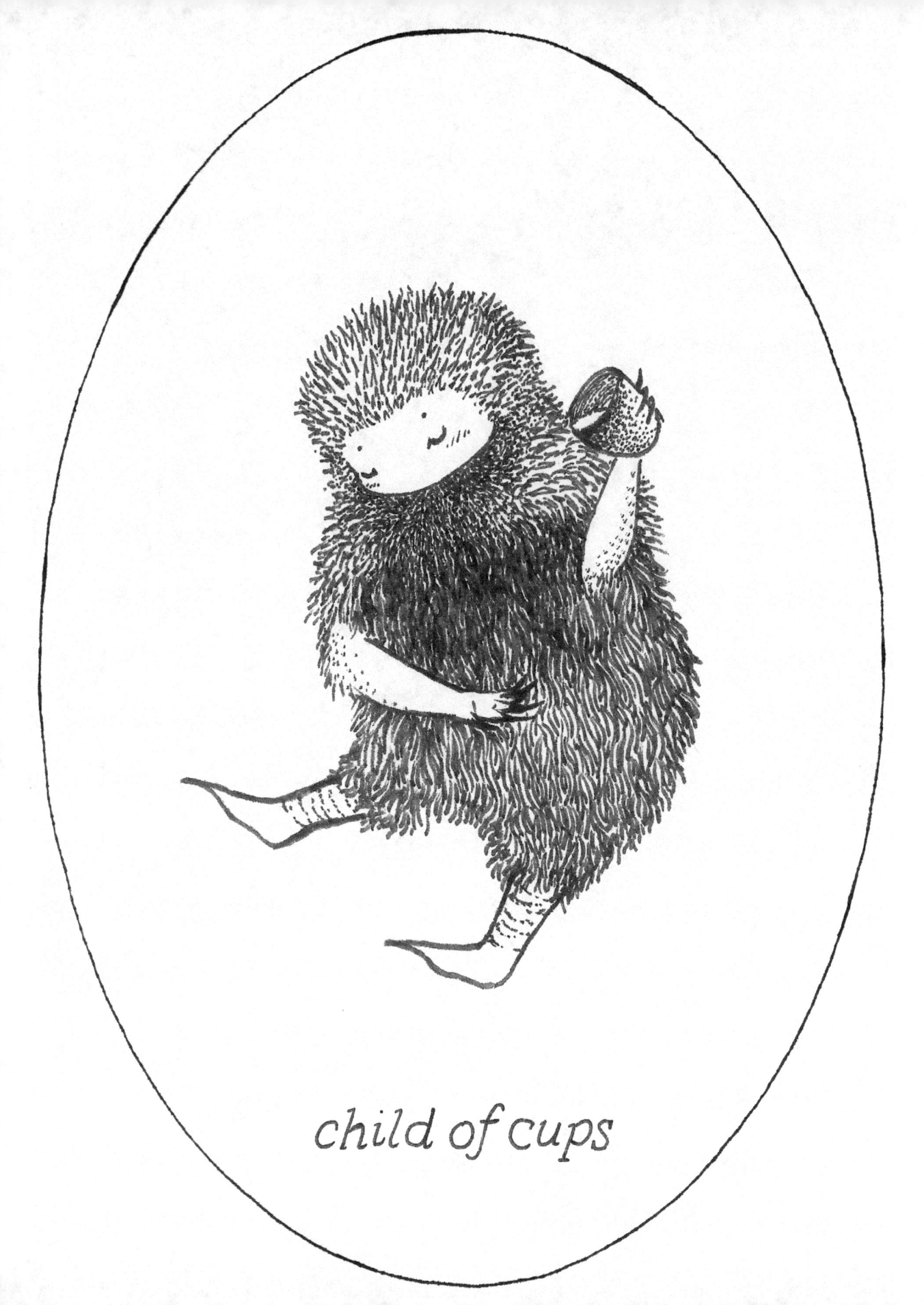

child of cups

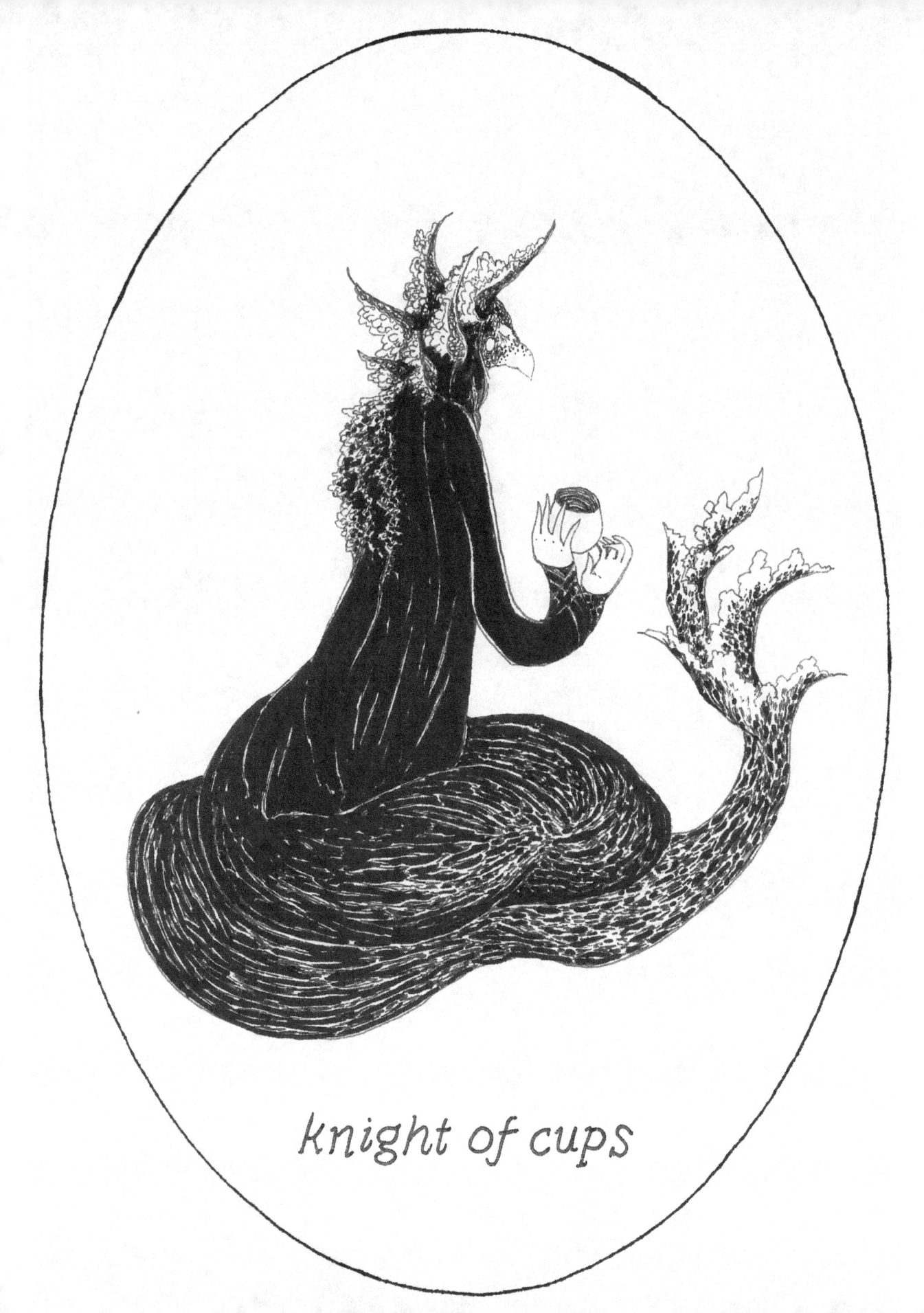
knight of cups

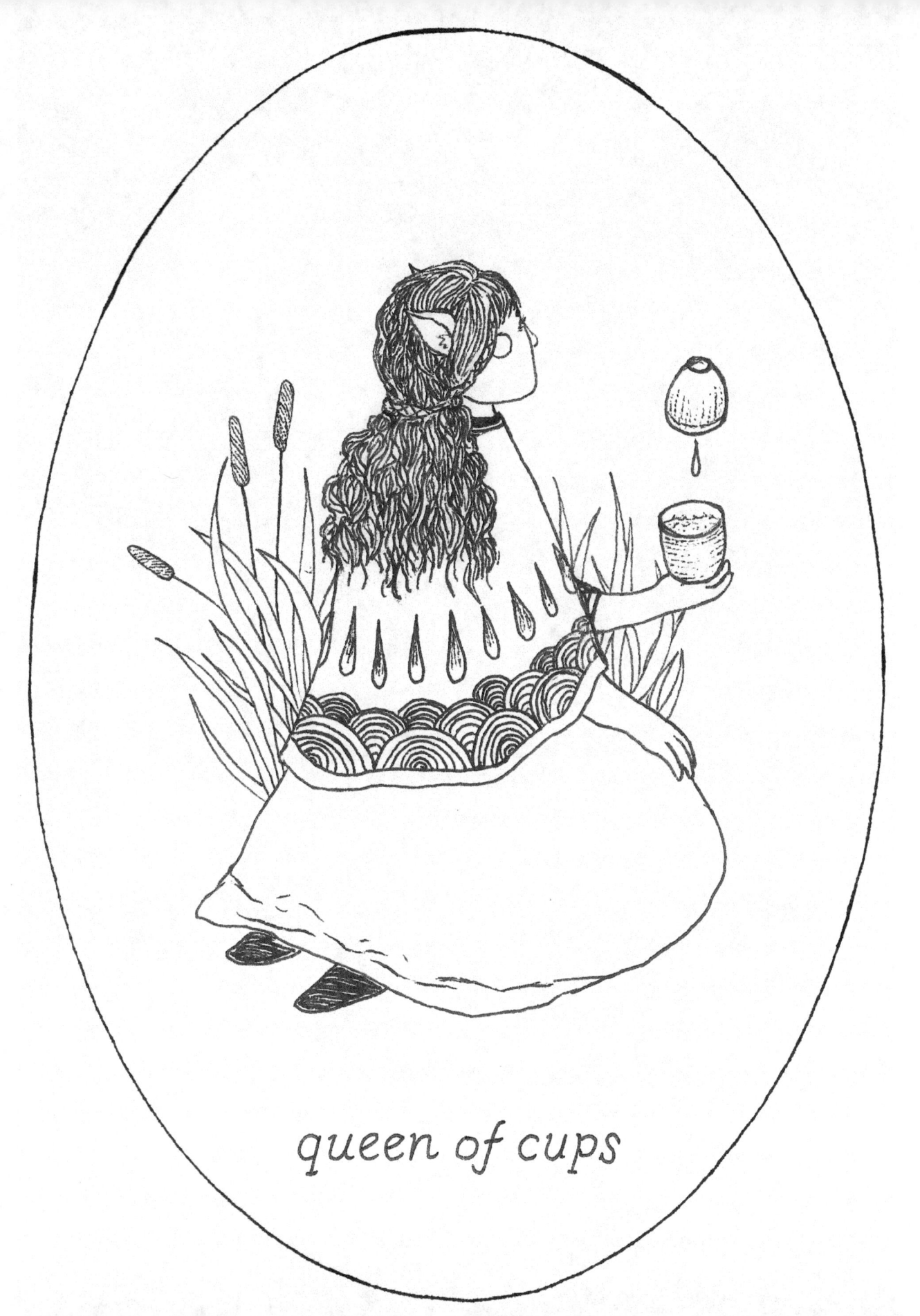

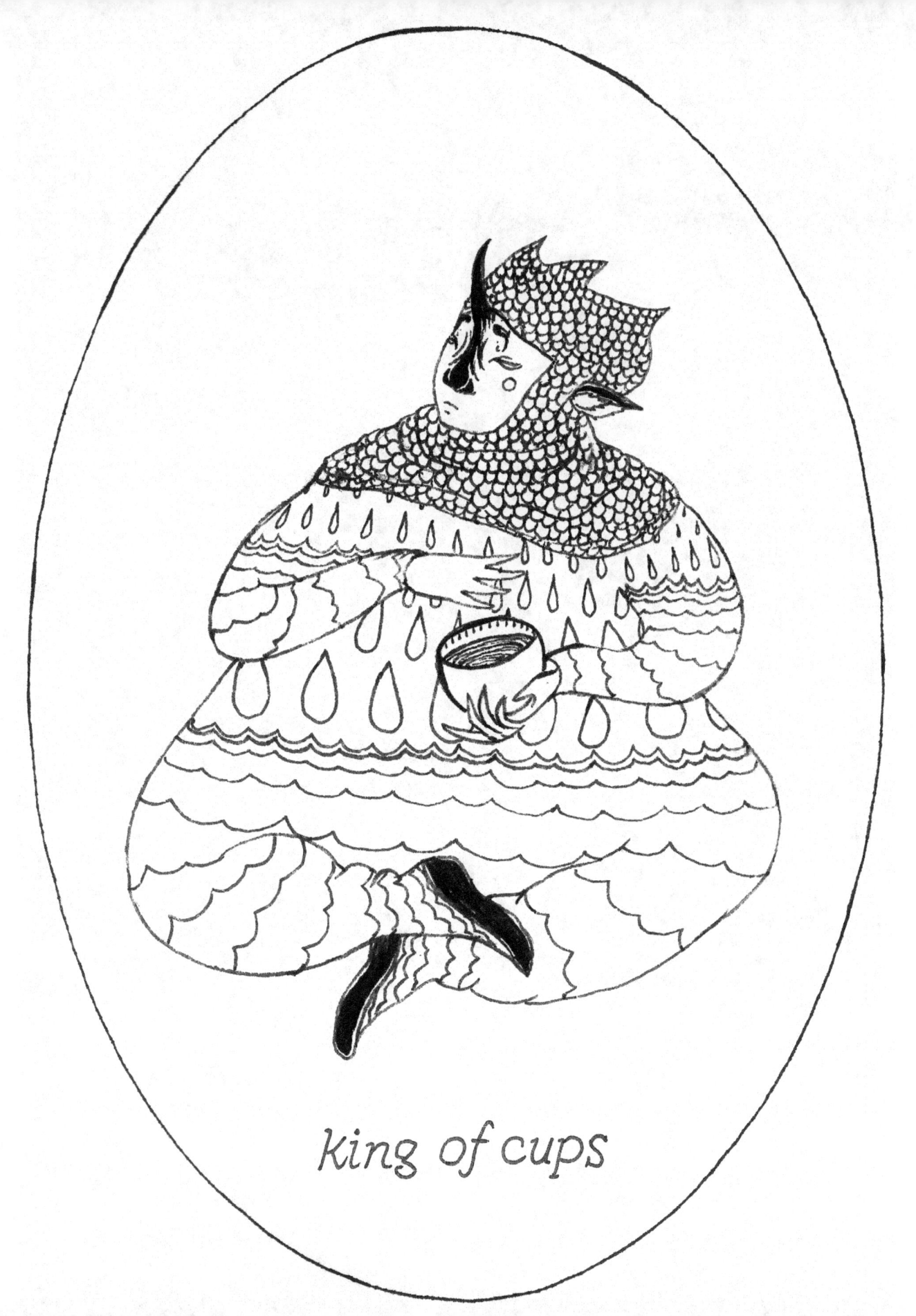

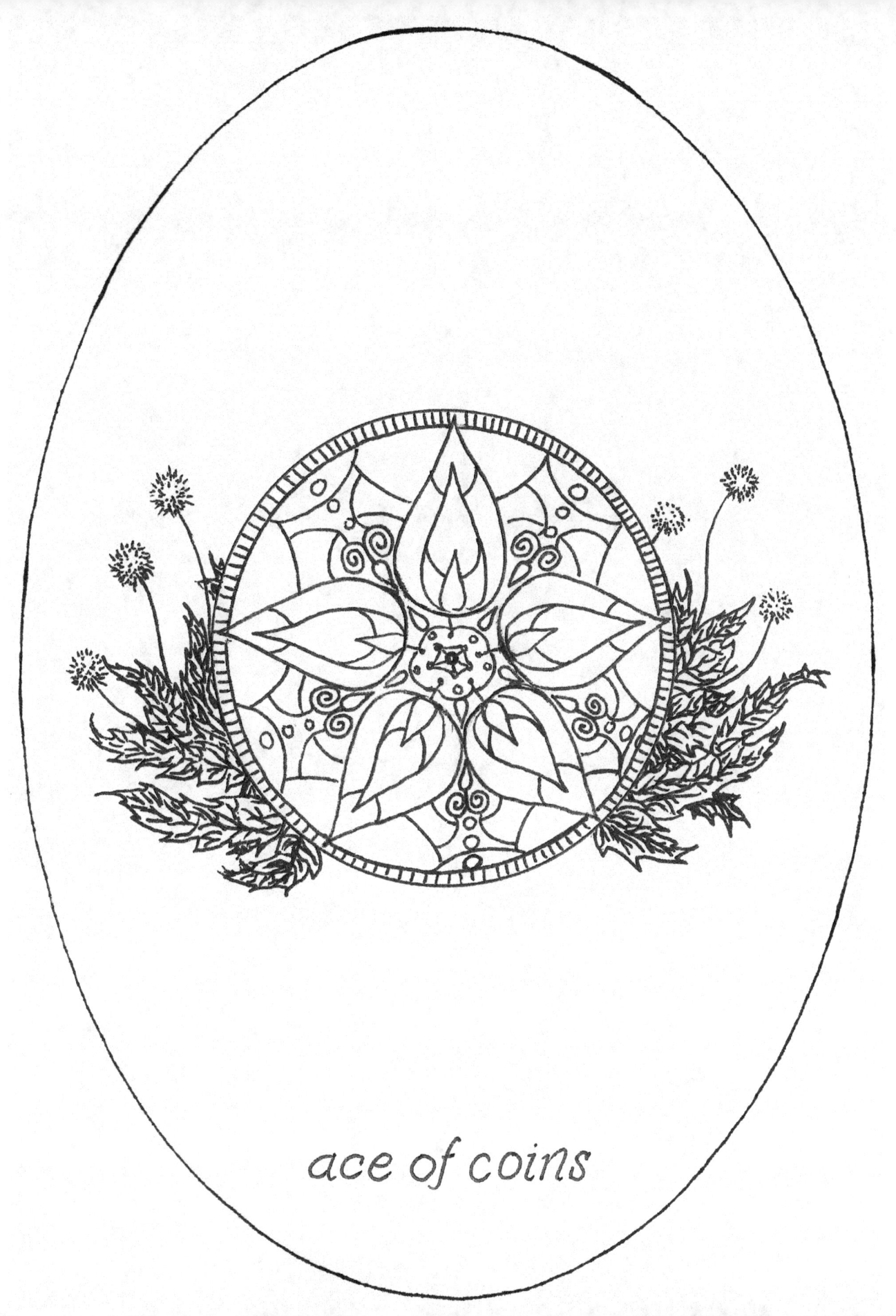

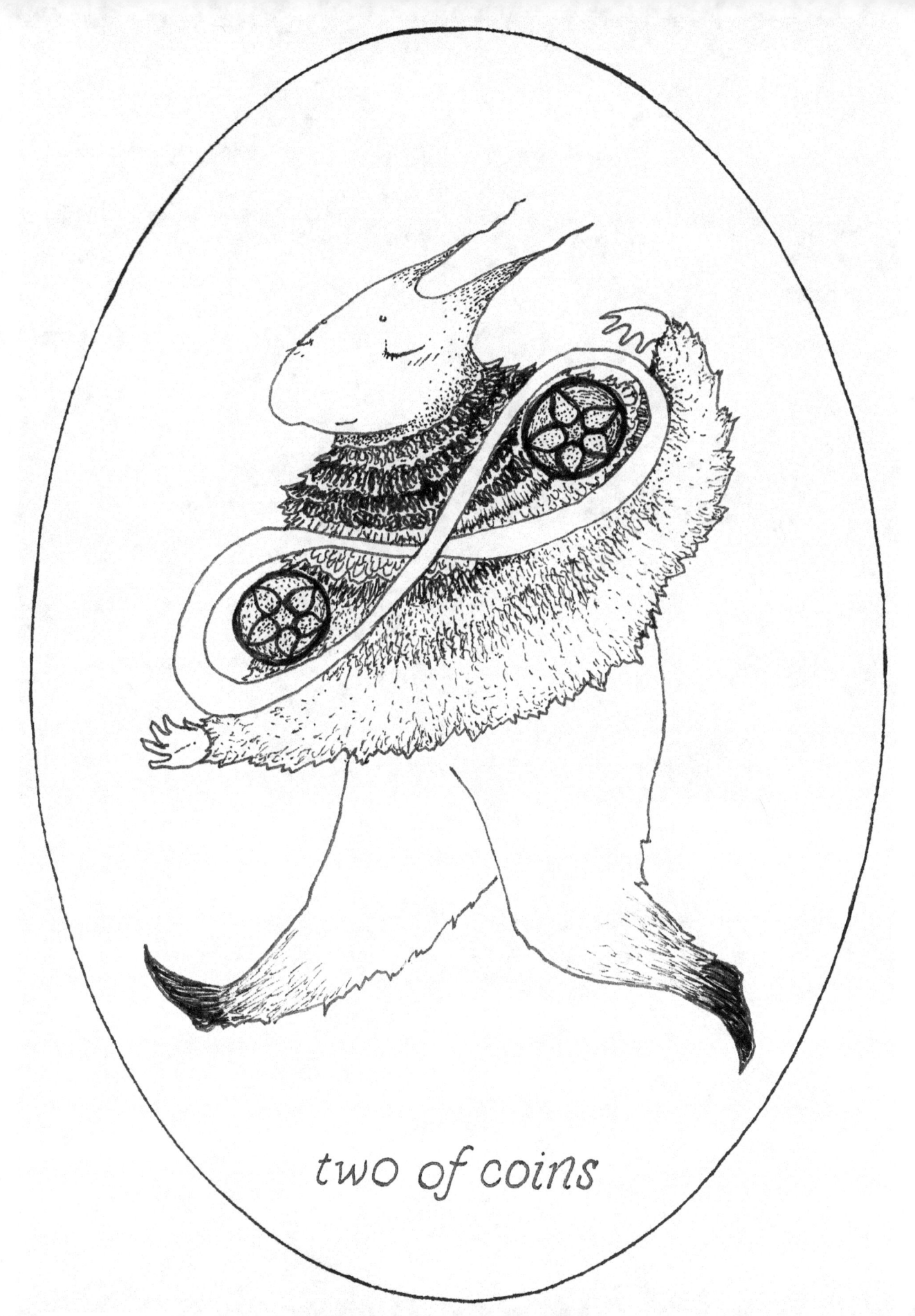

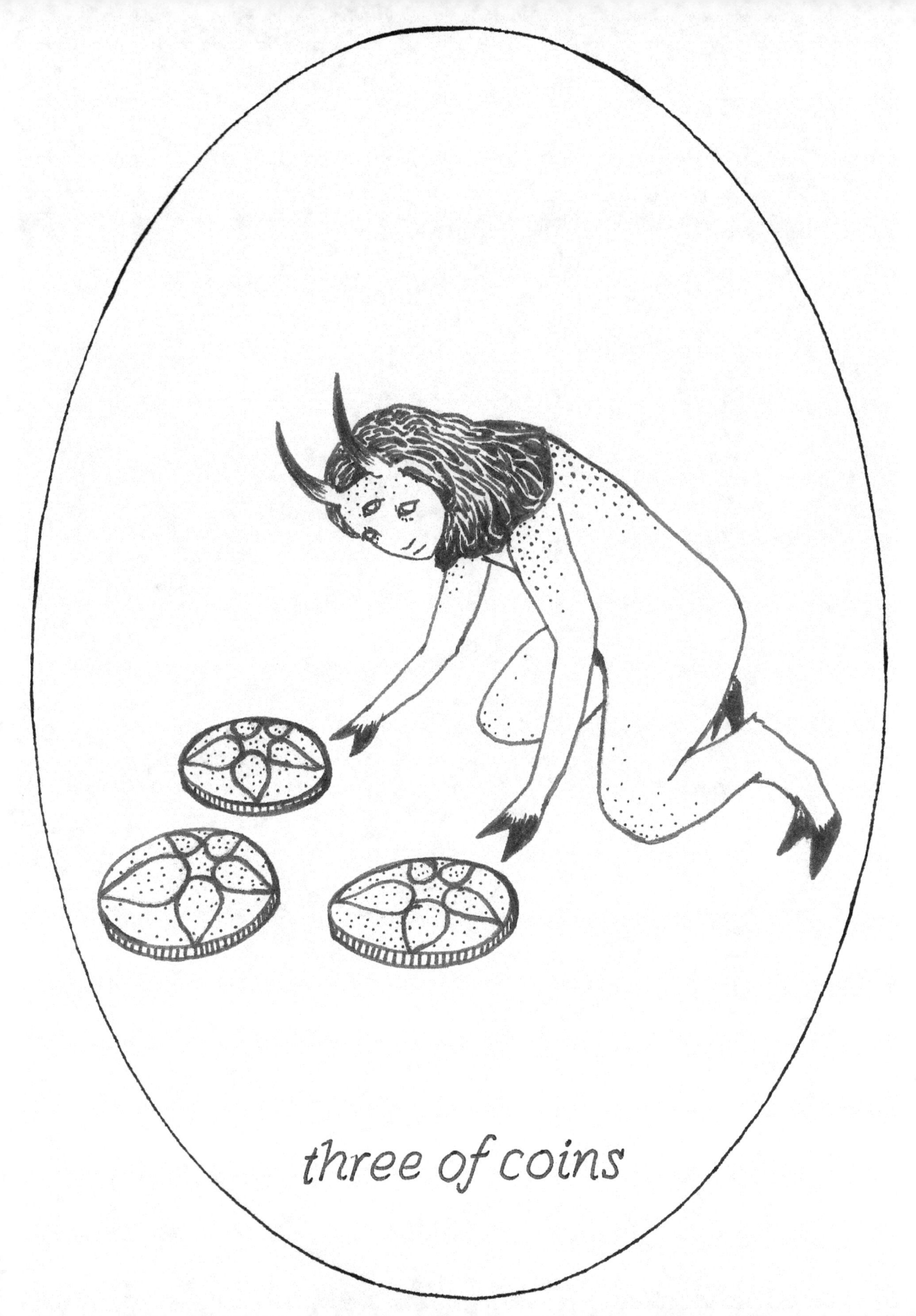

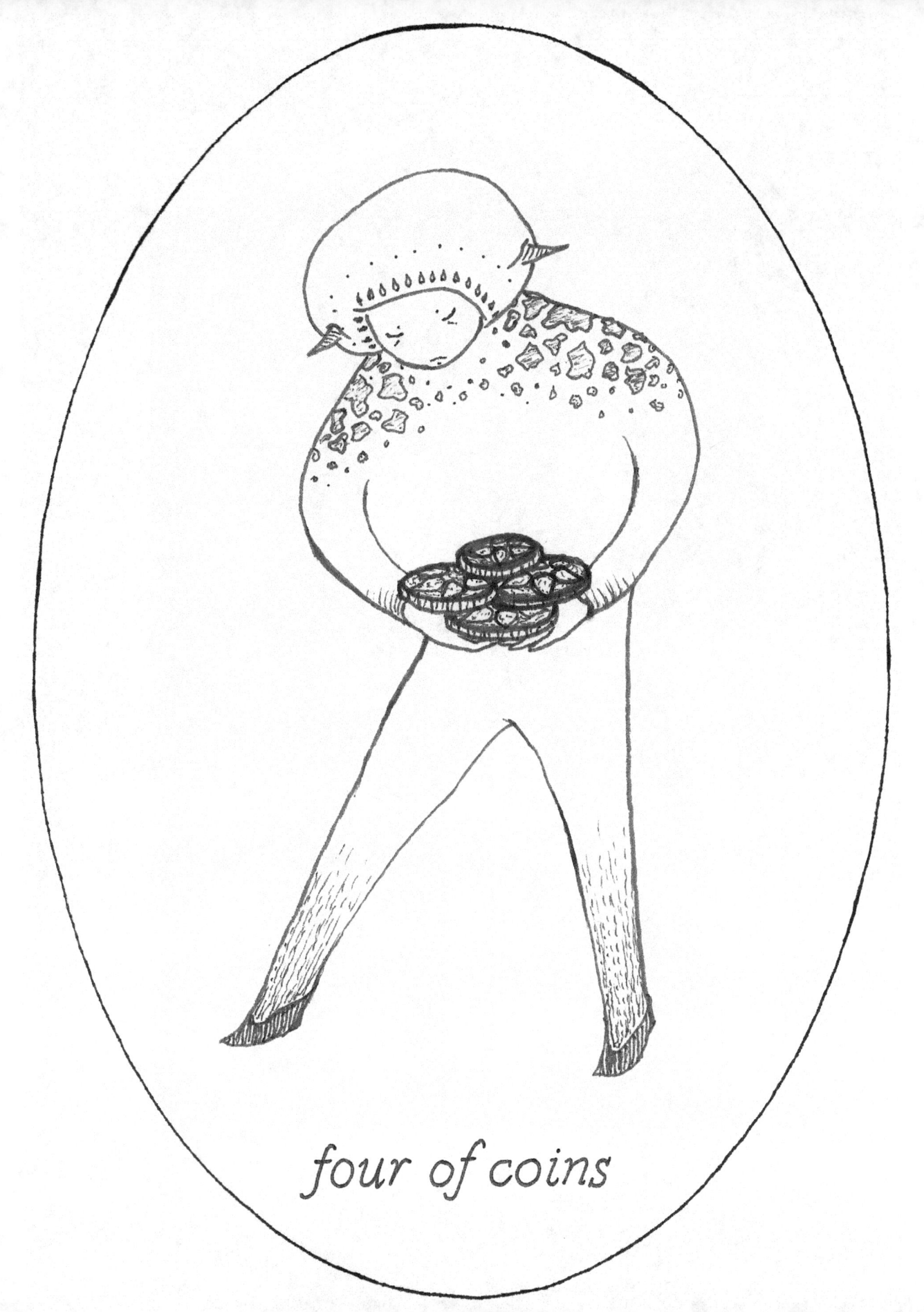

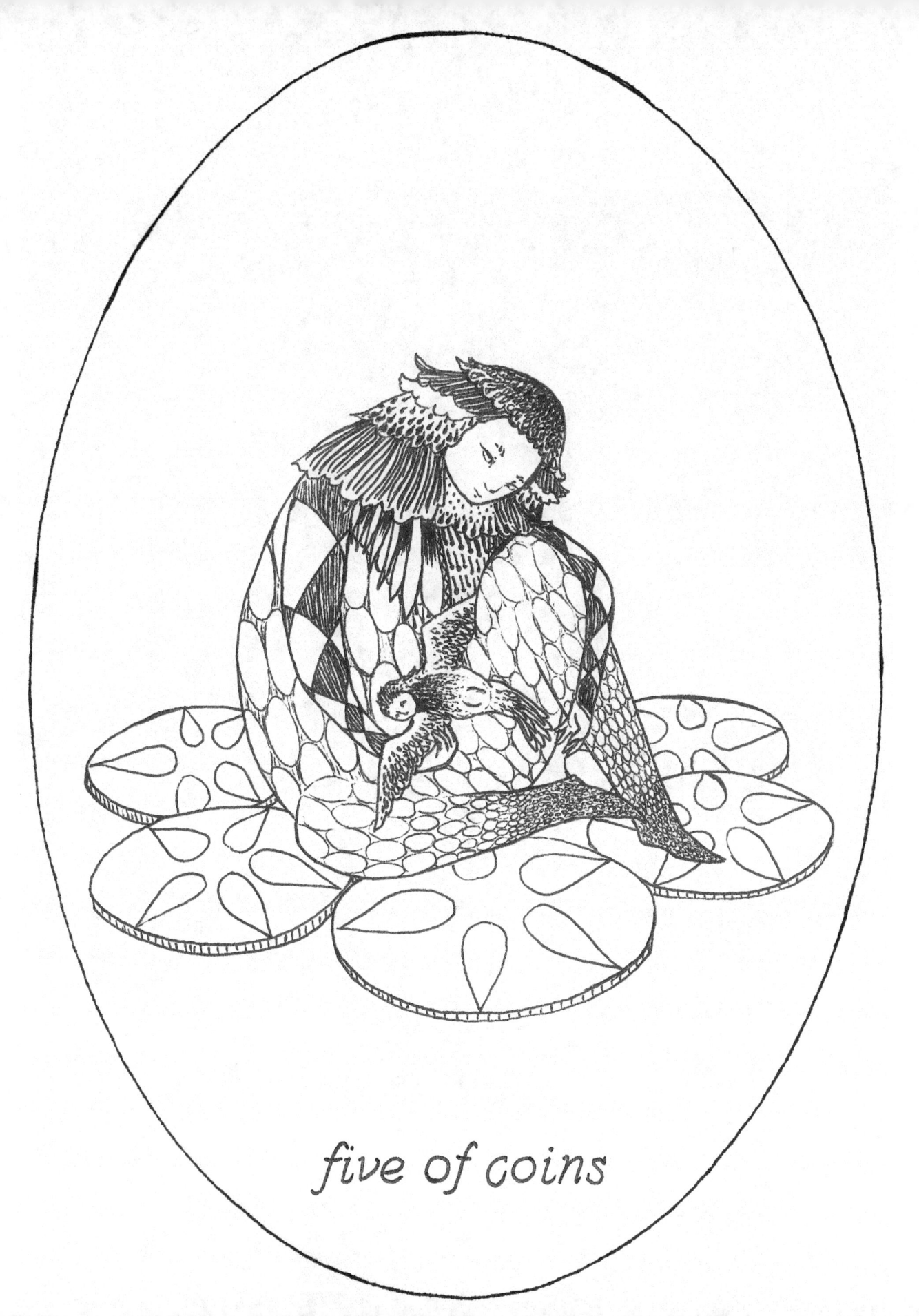

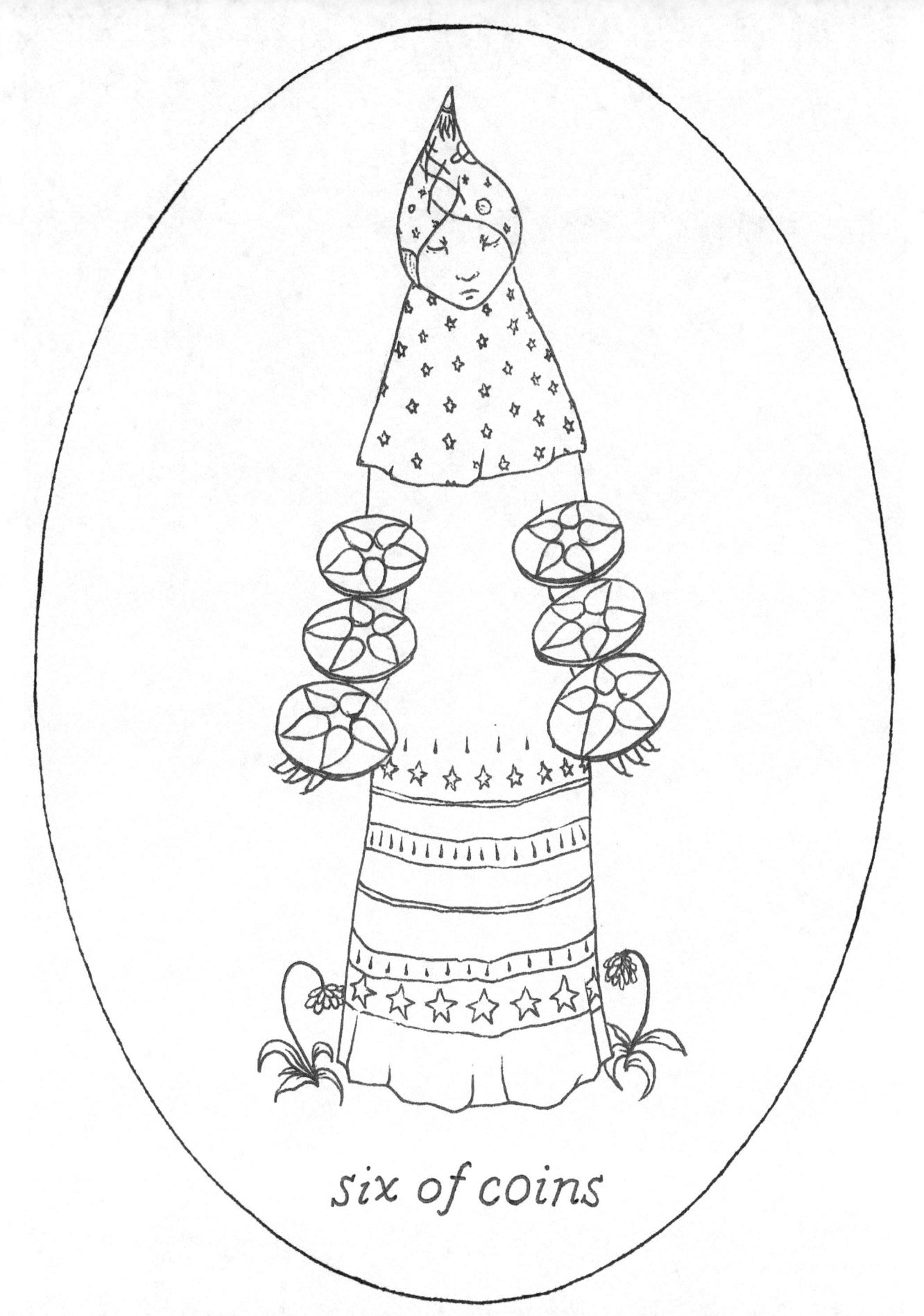

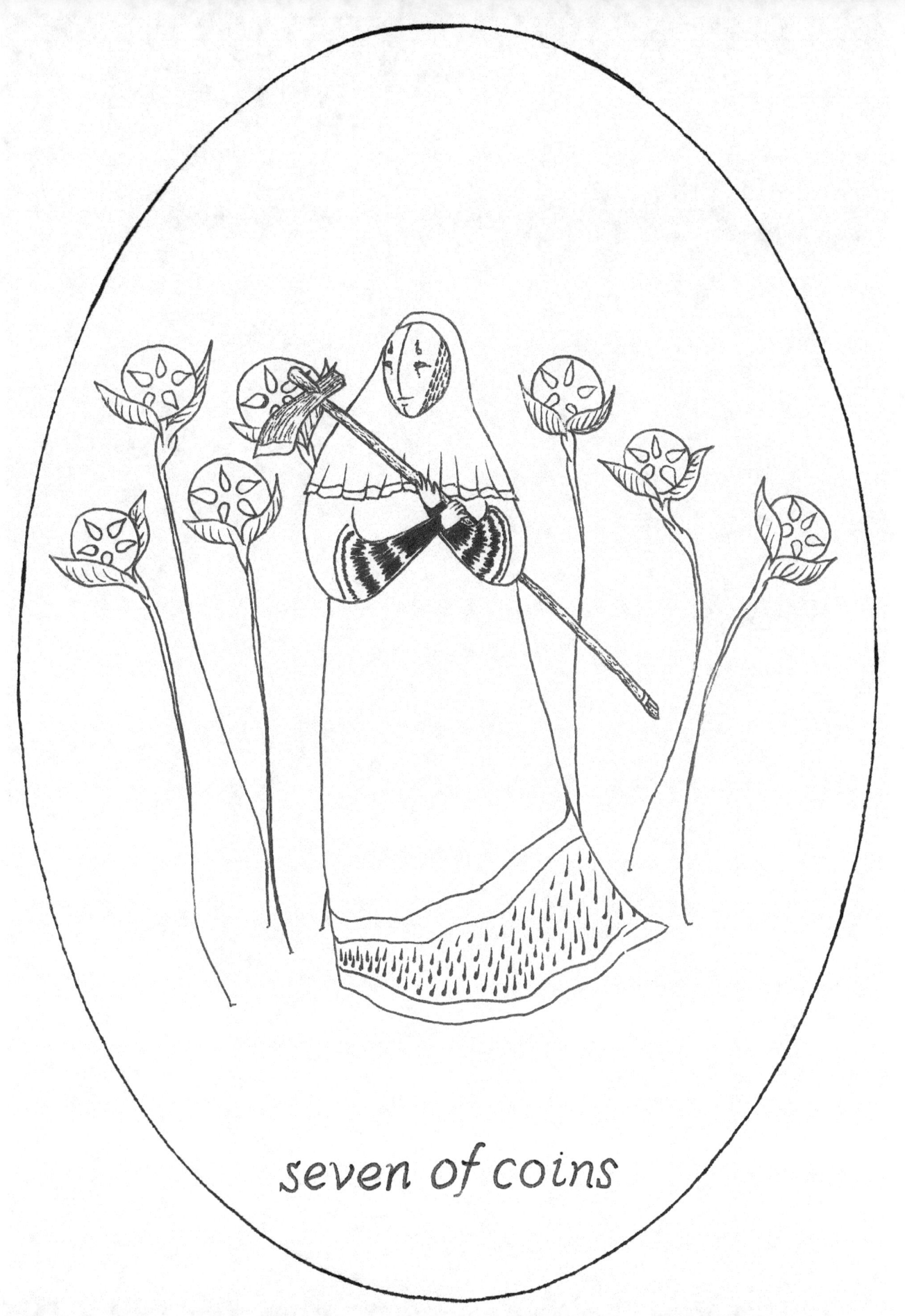

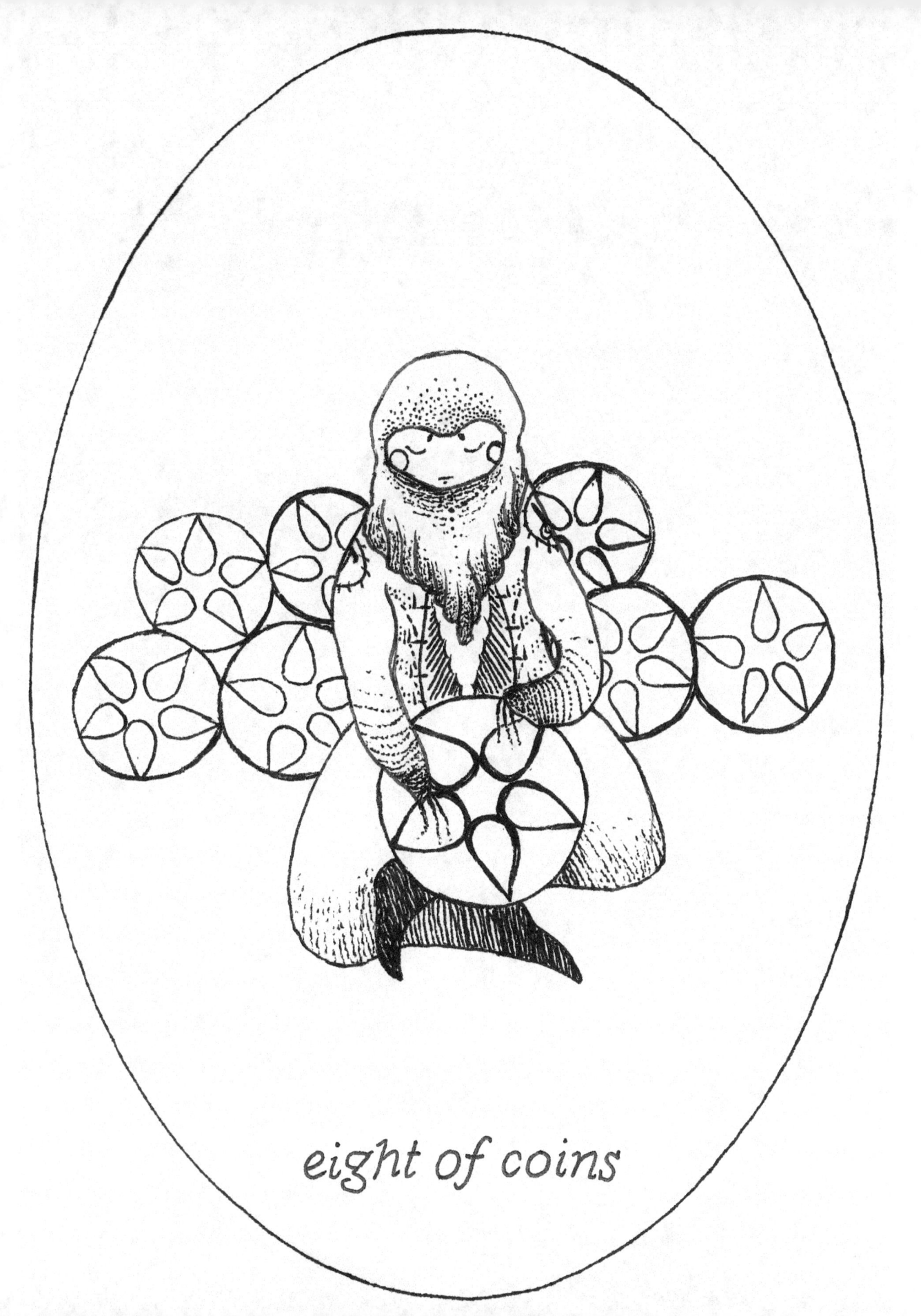

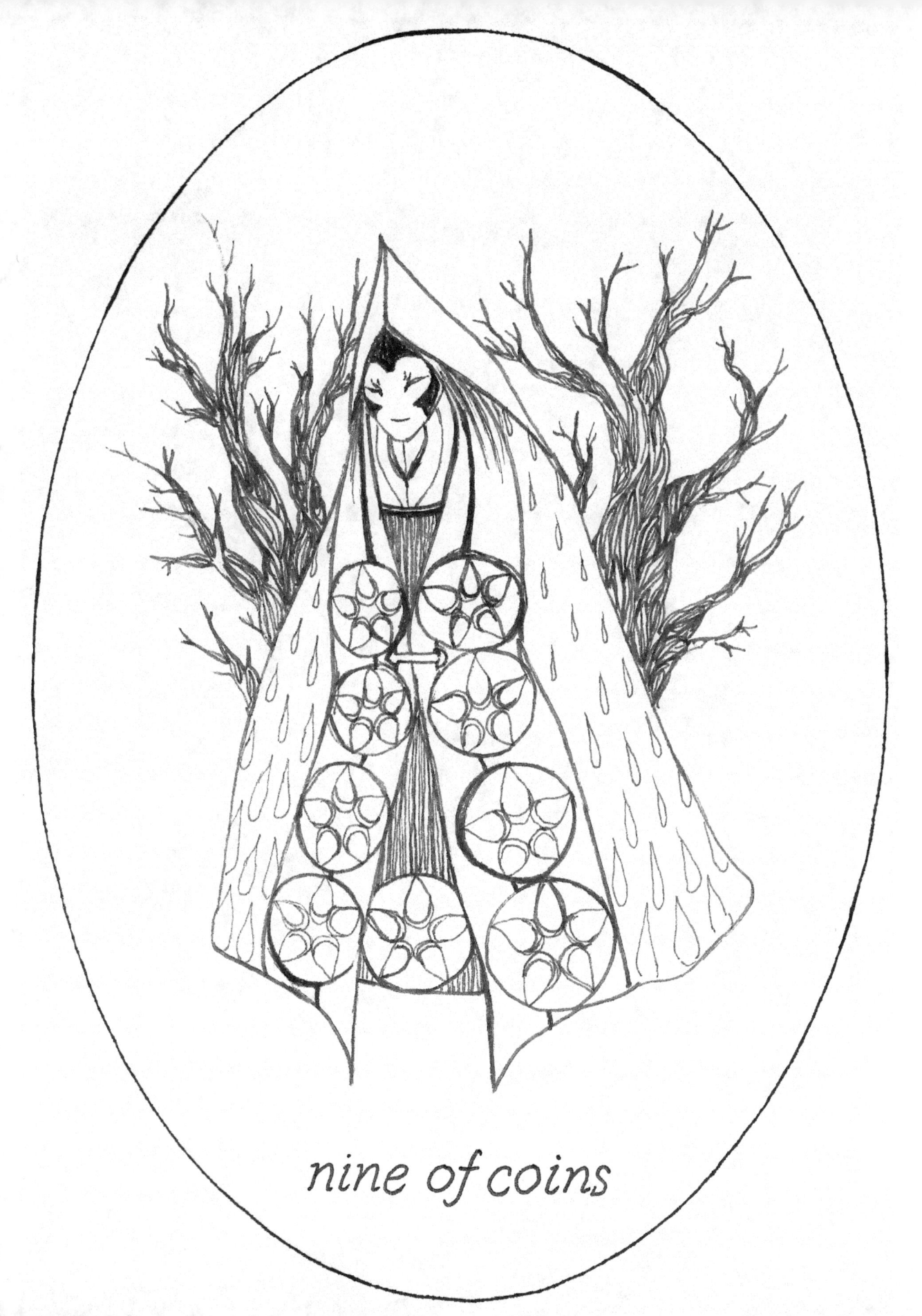

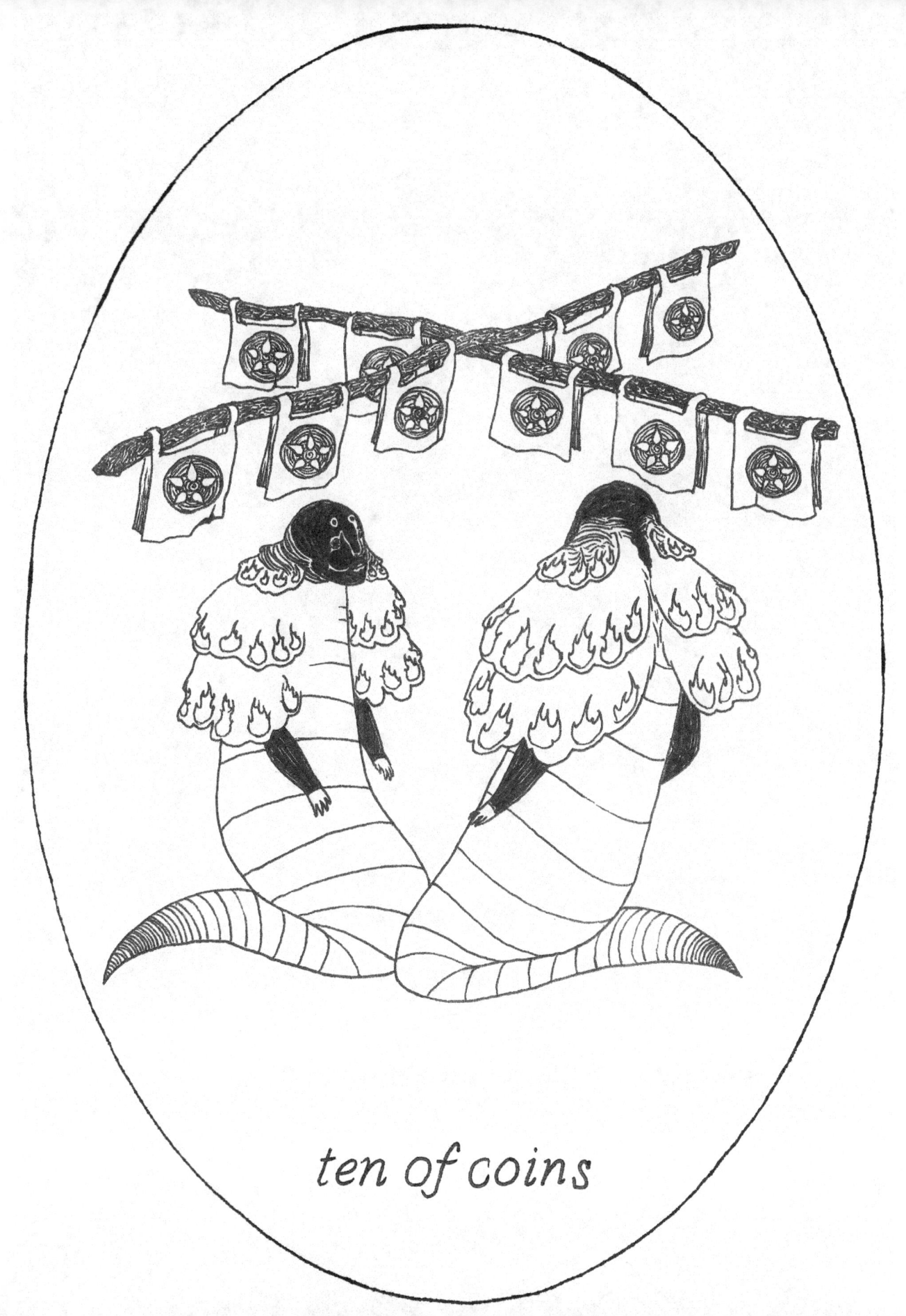

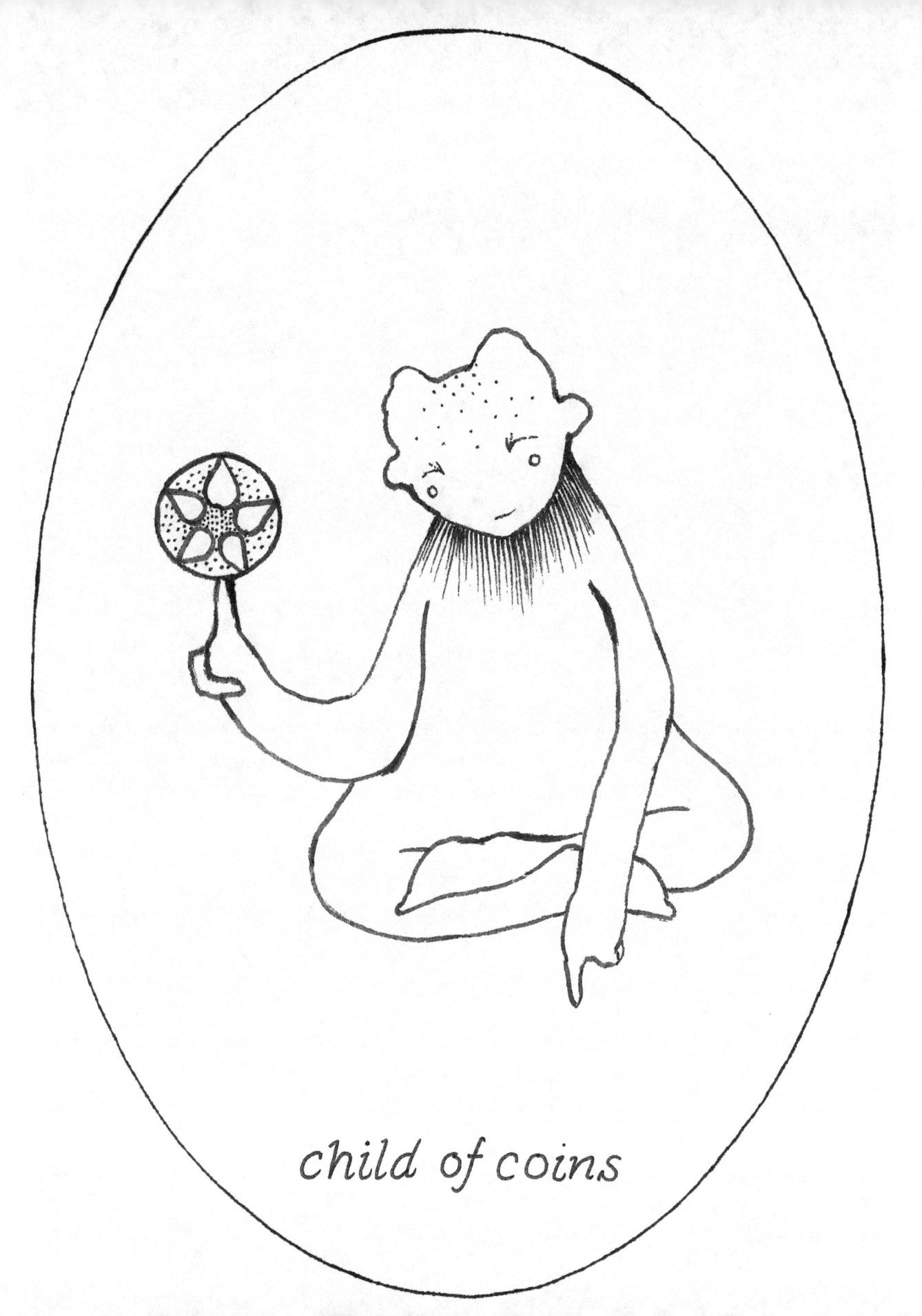

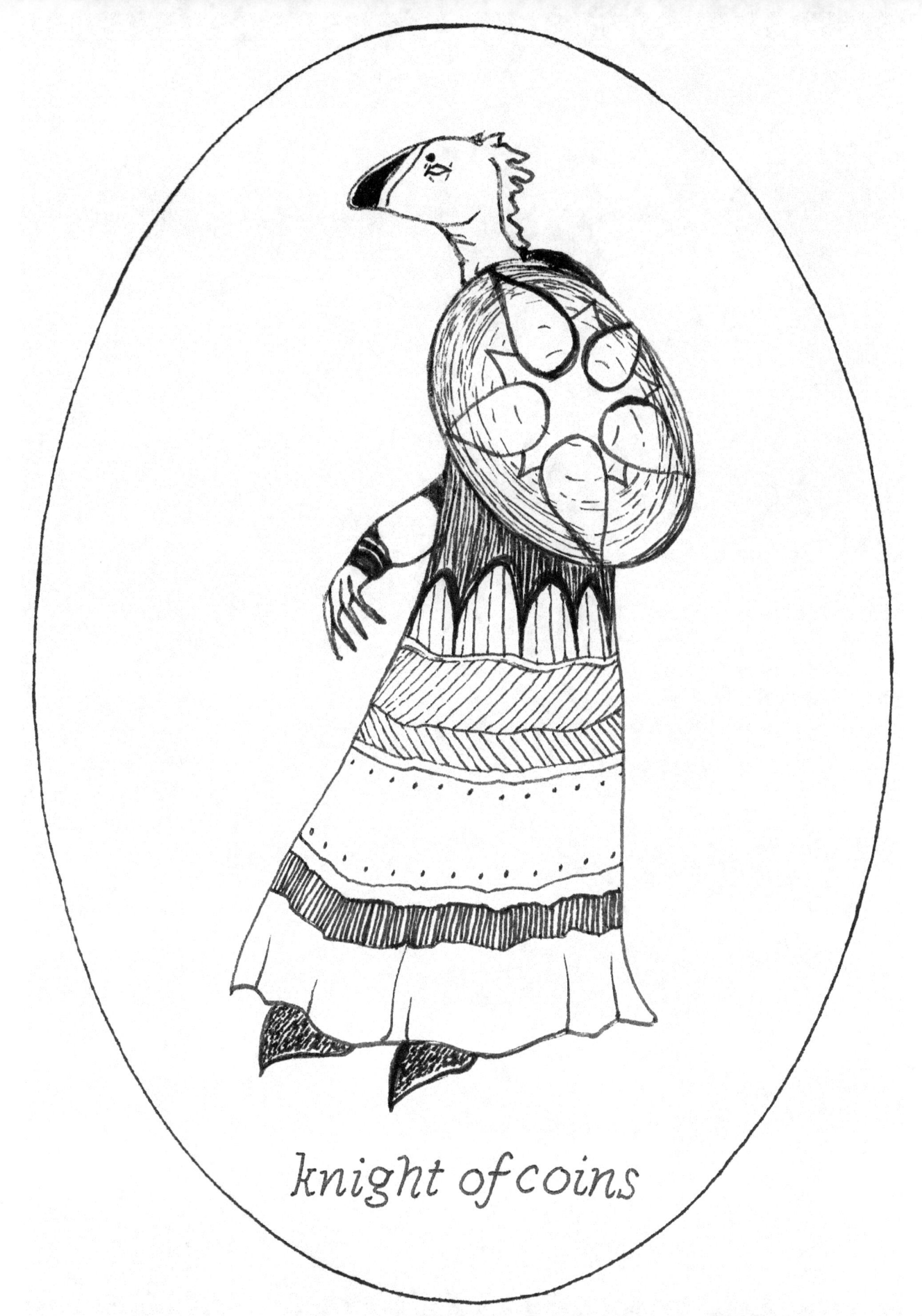

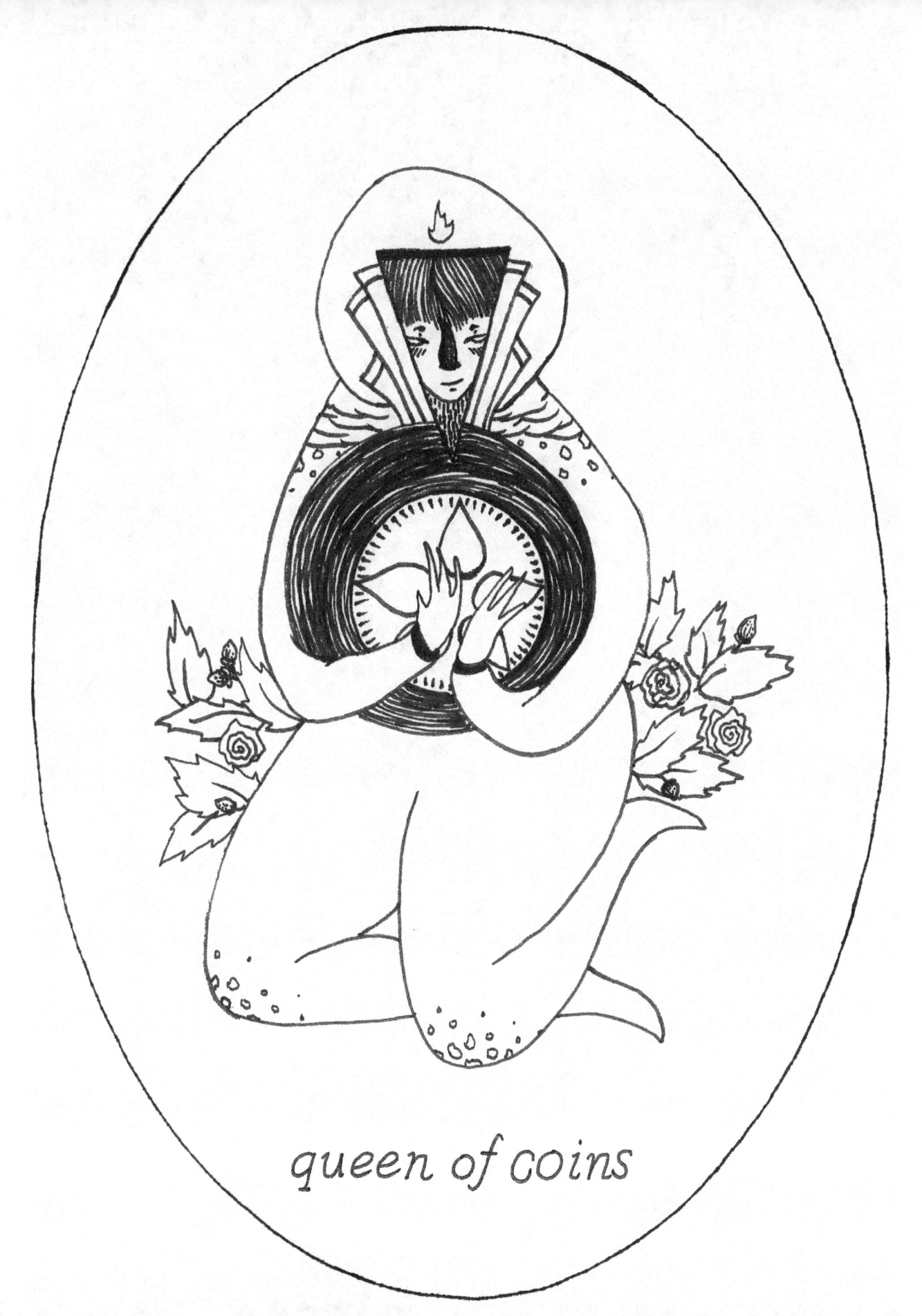

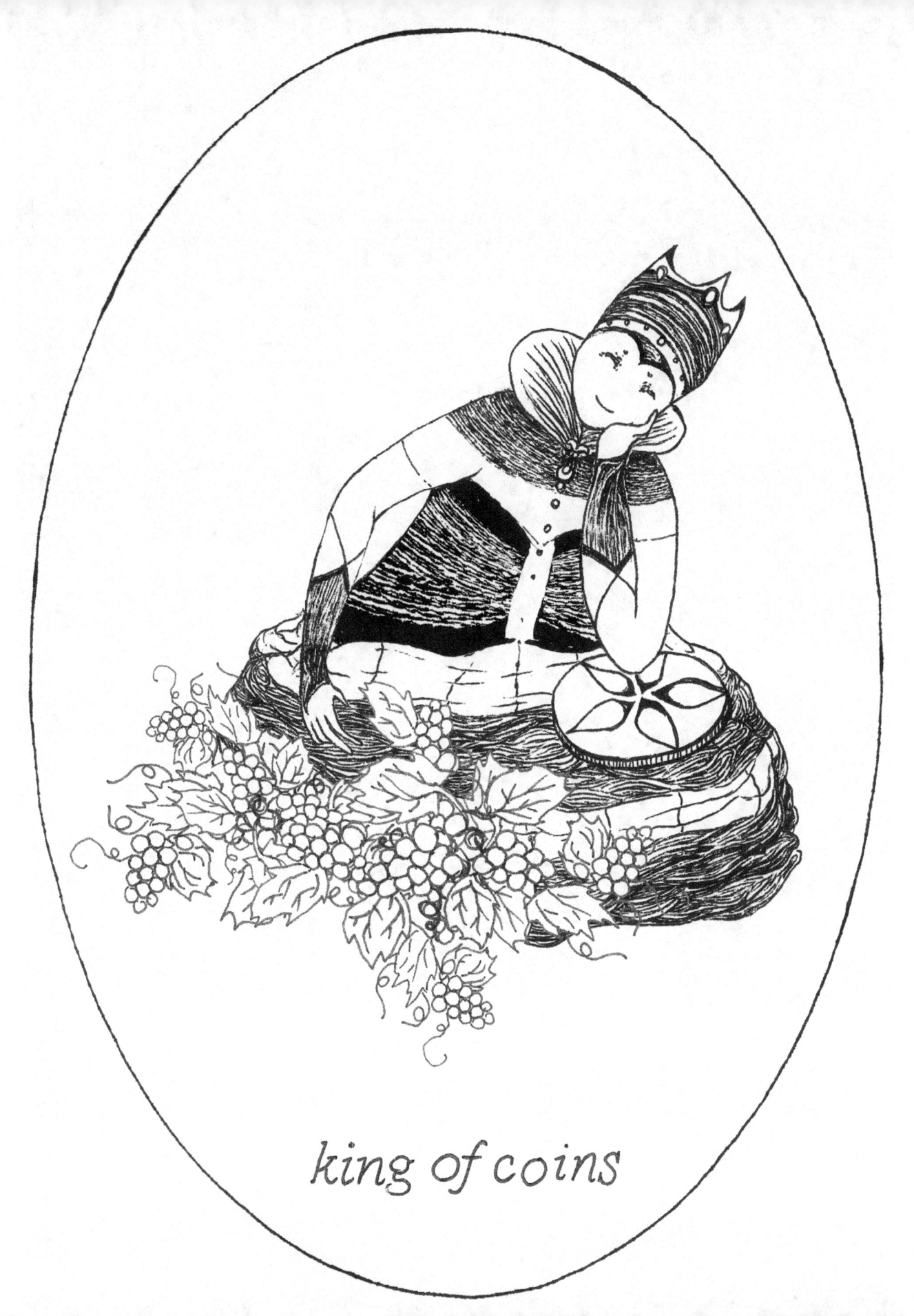

king of coins

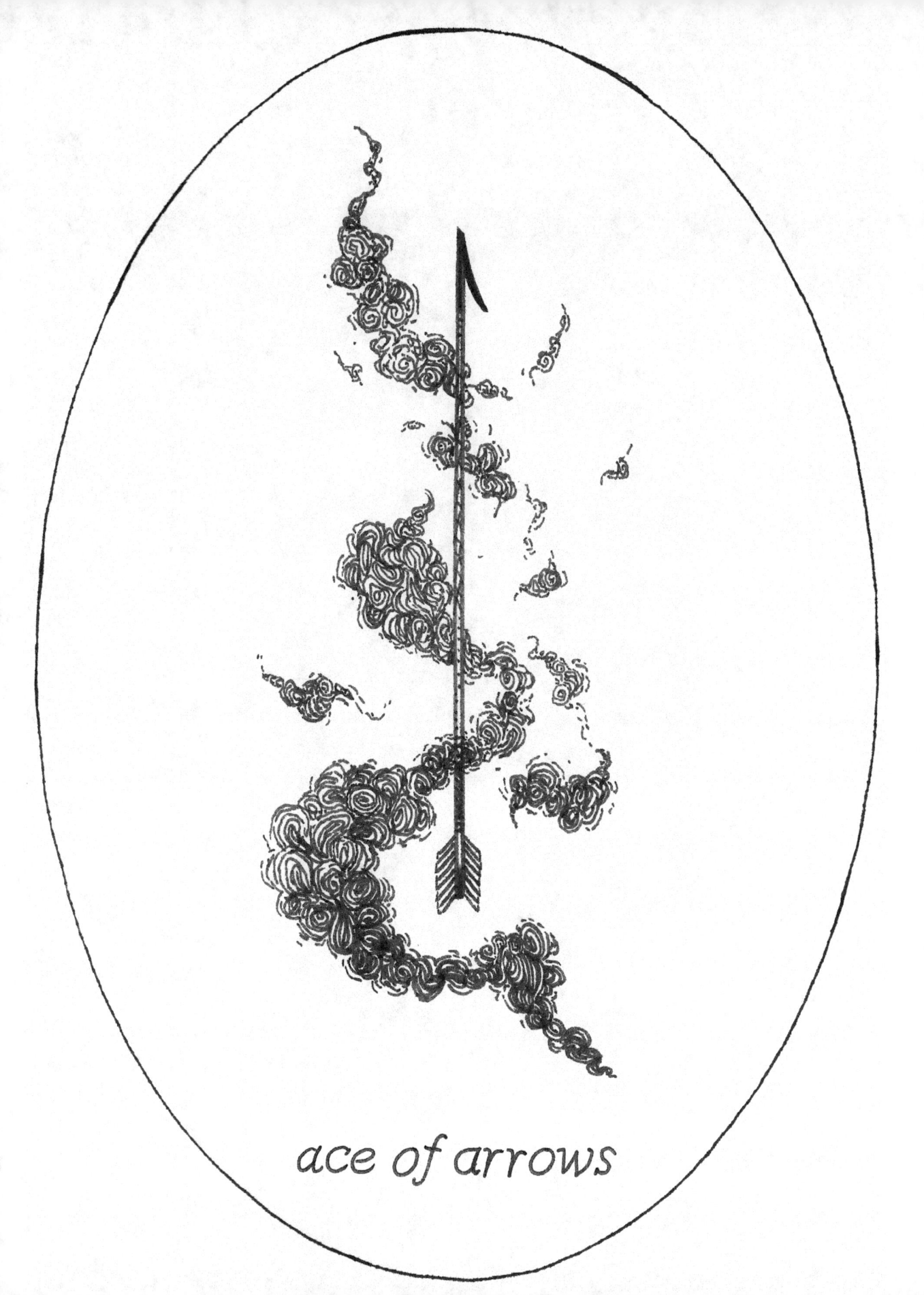

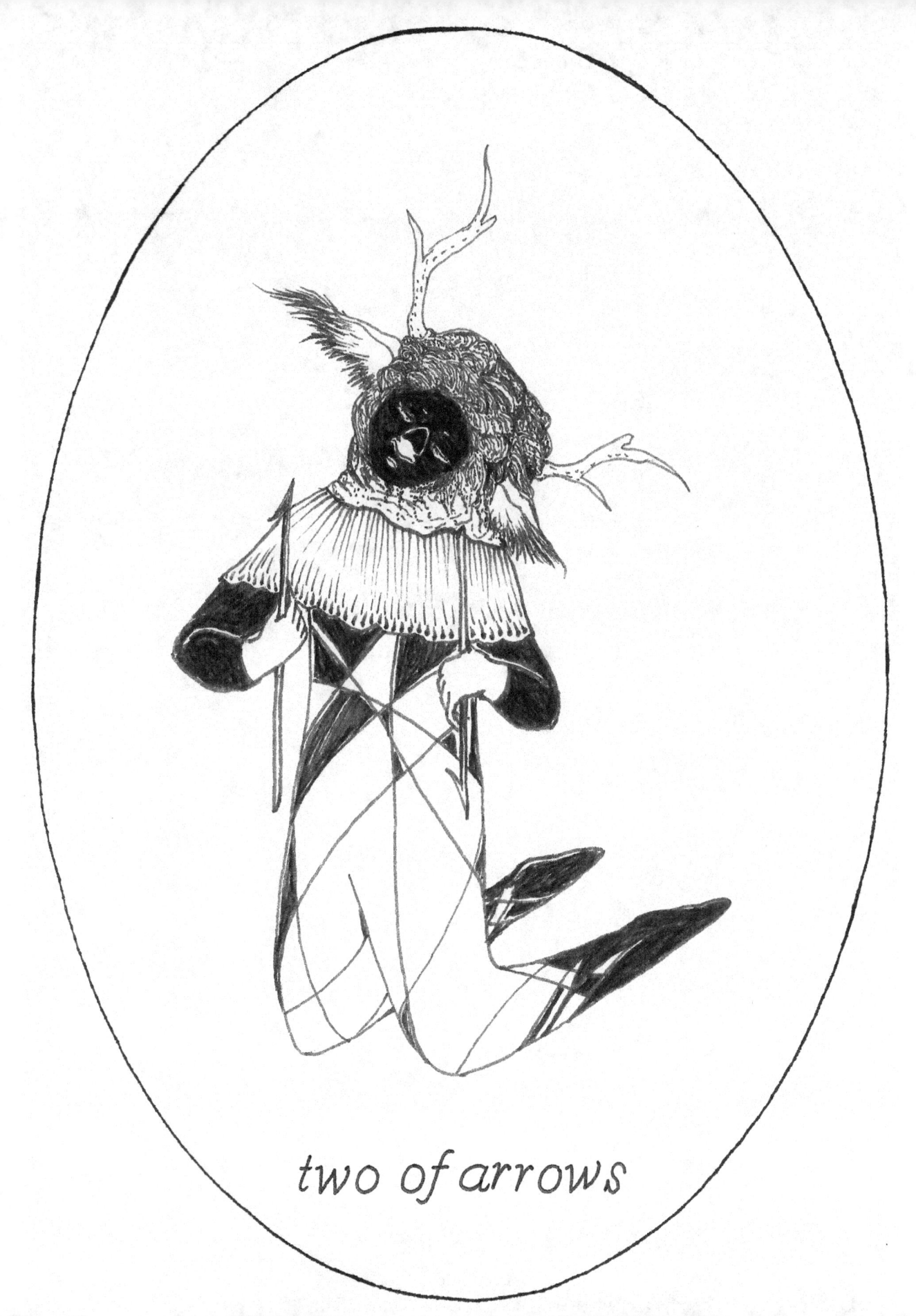

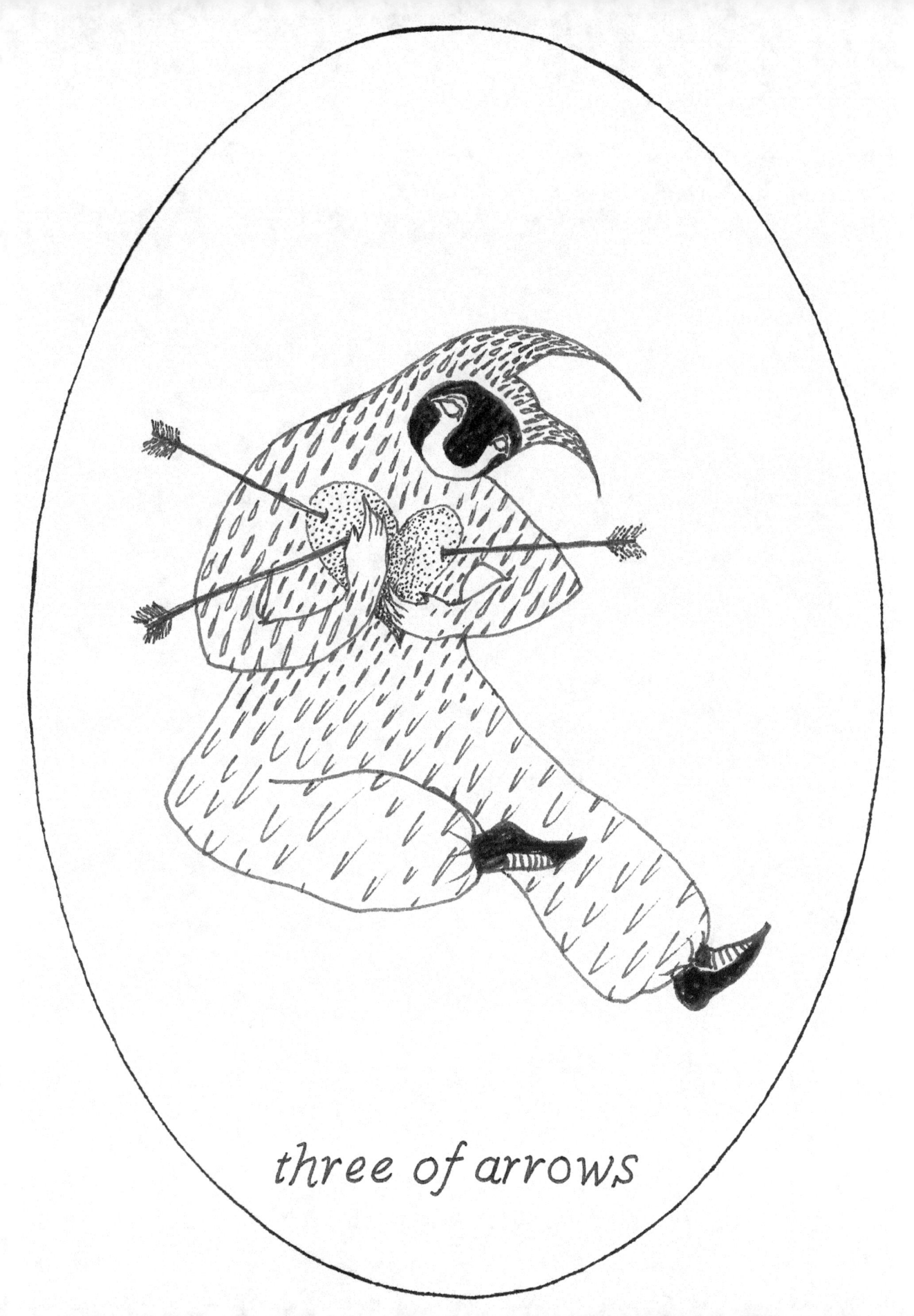

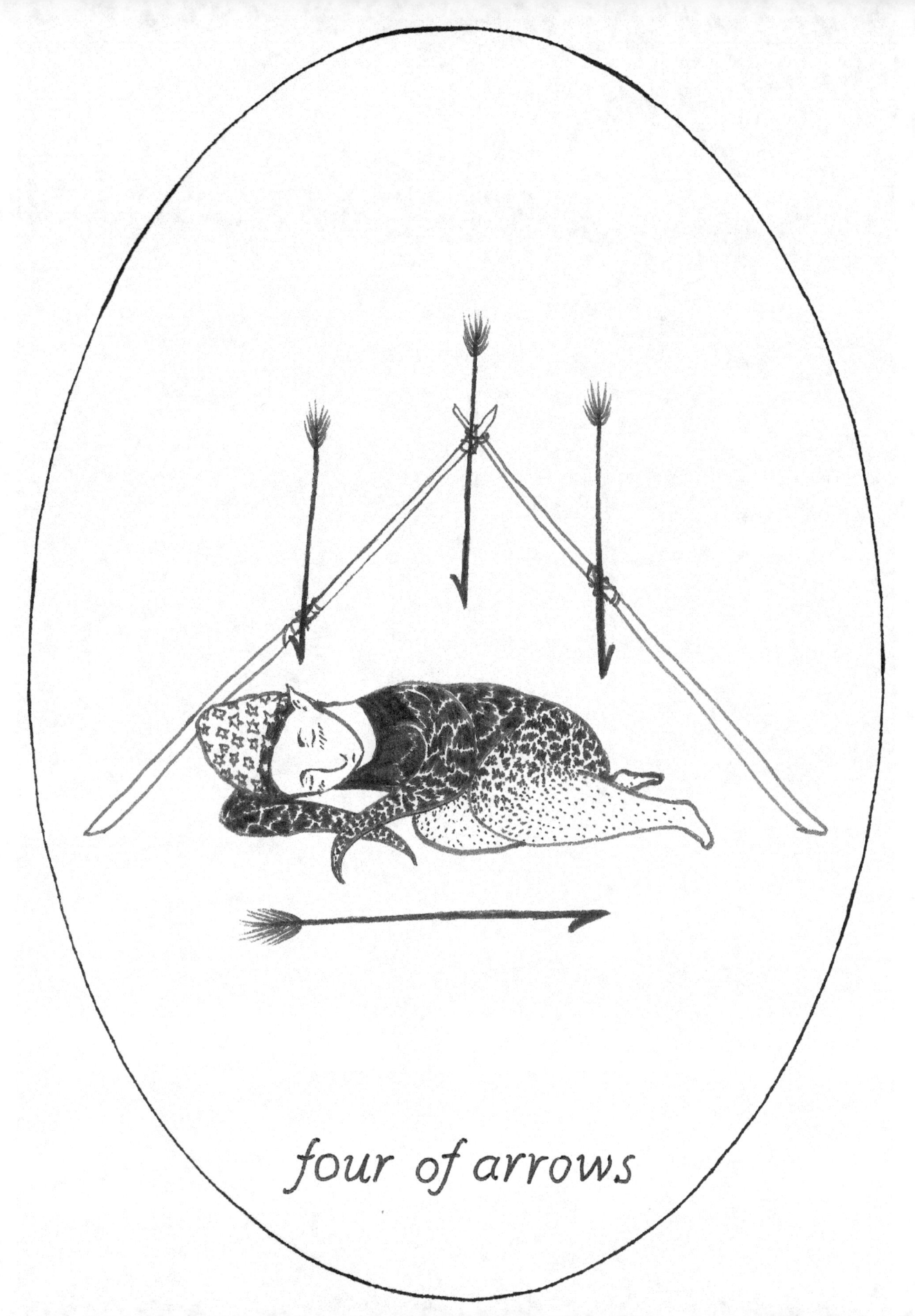

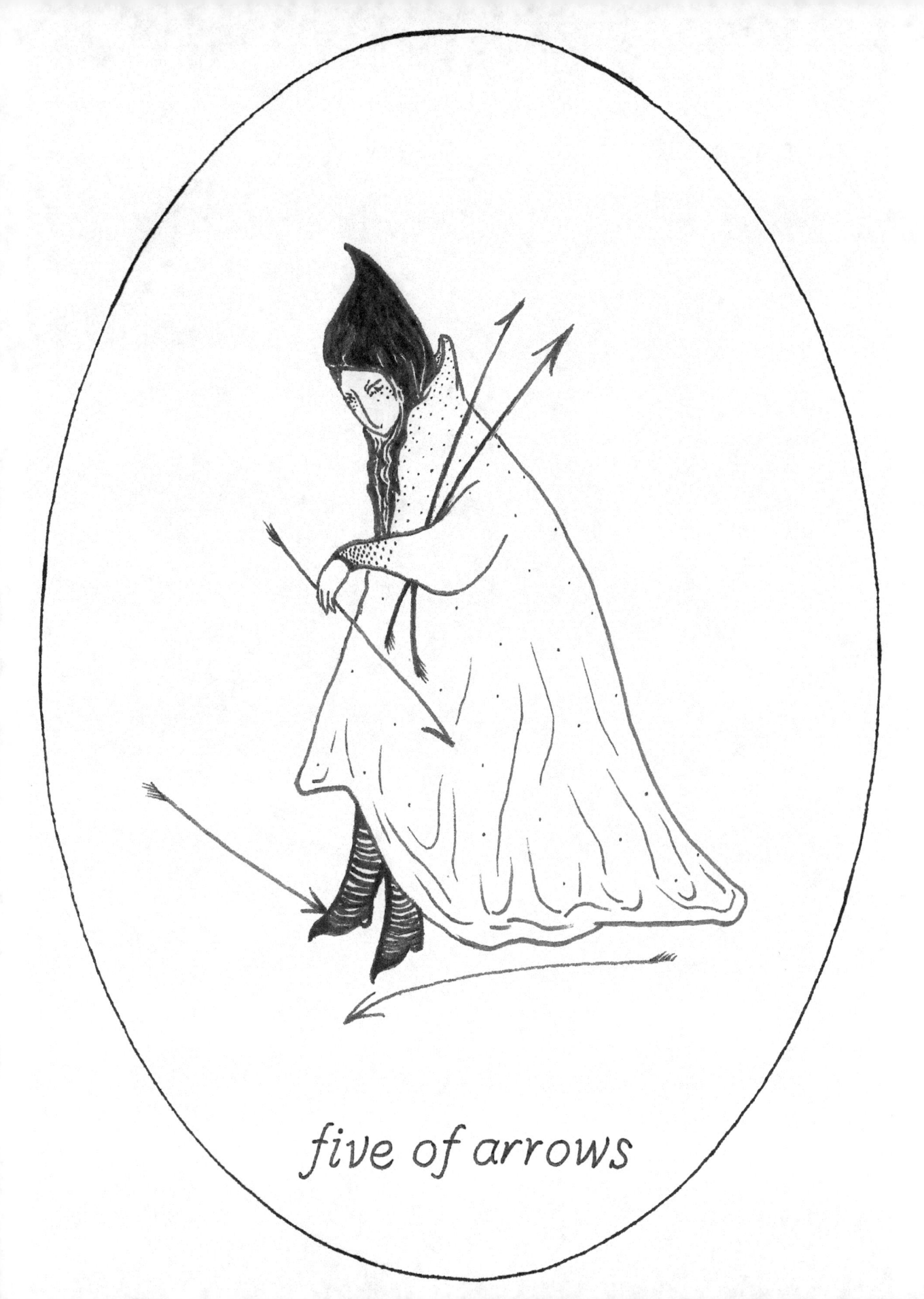

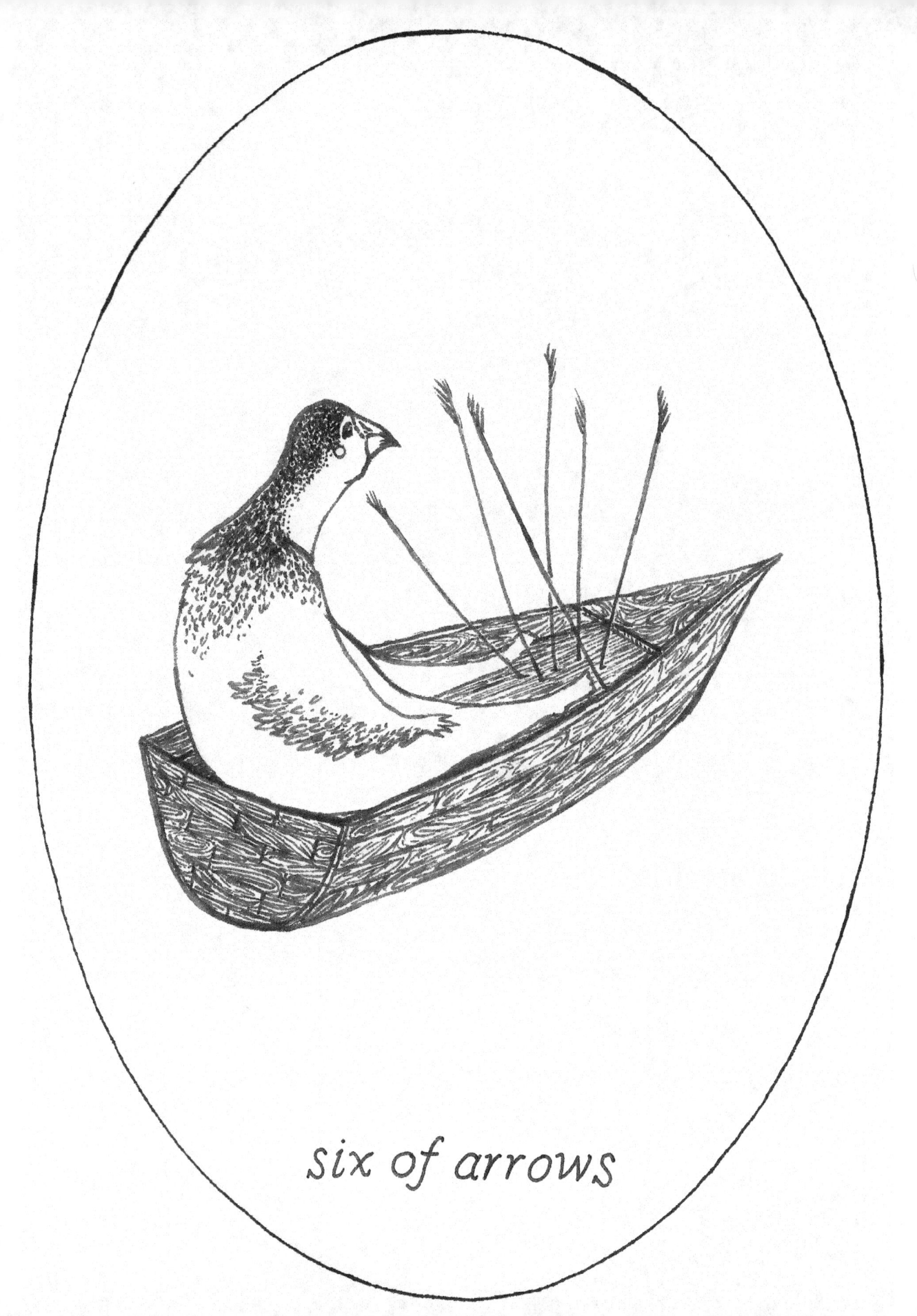

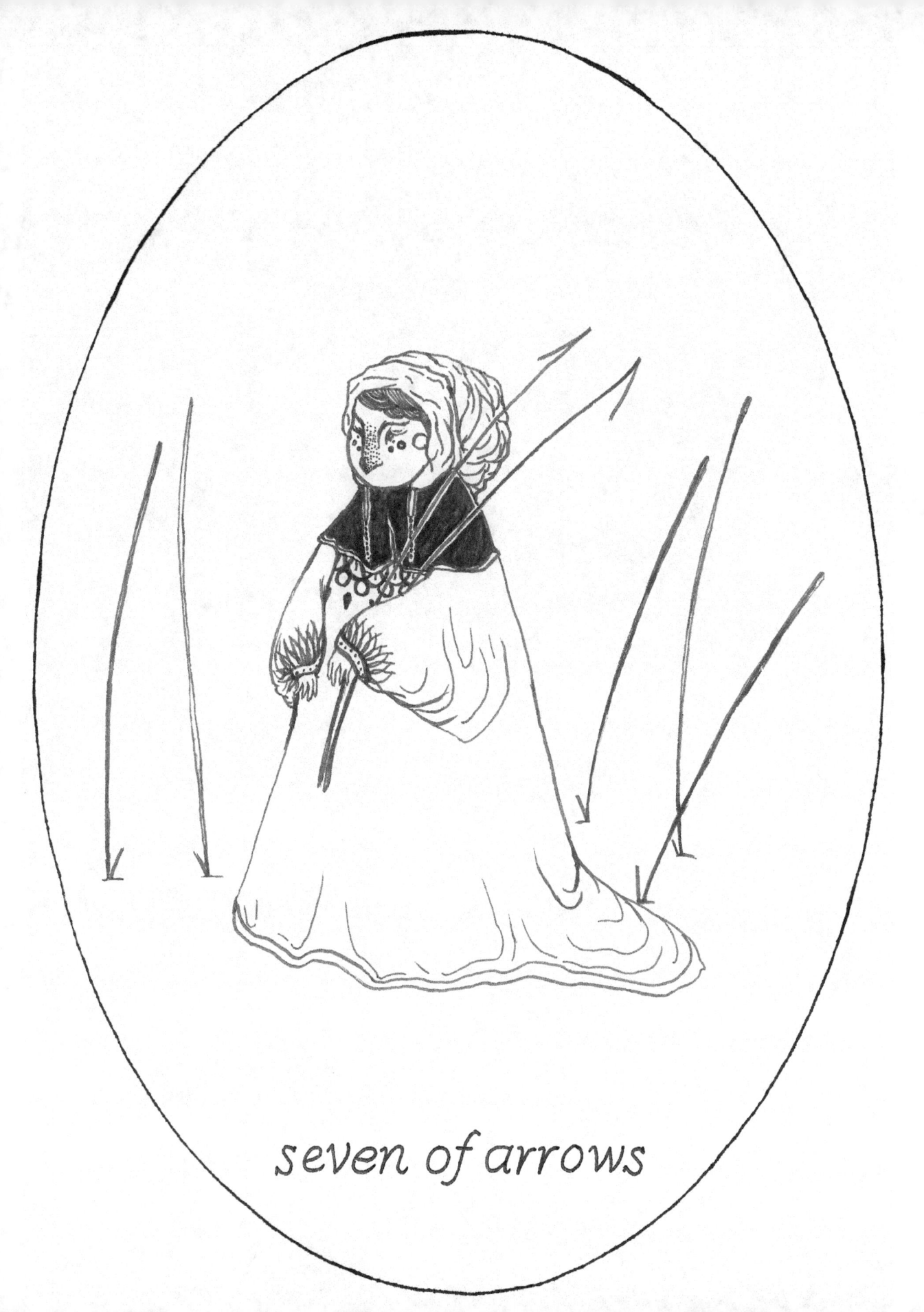

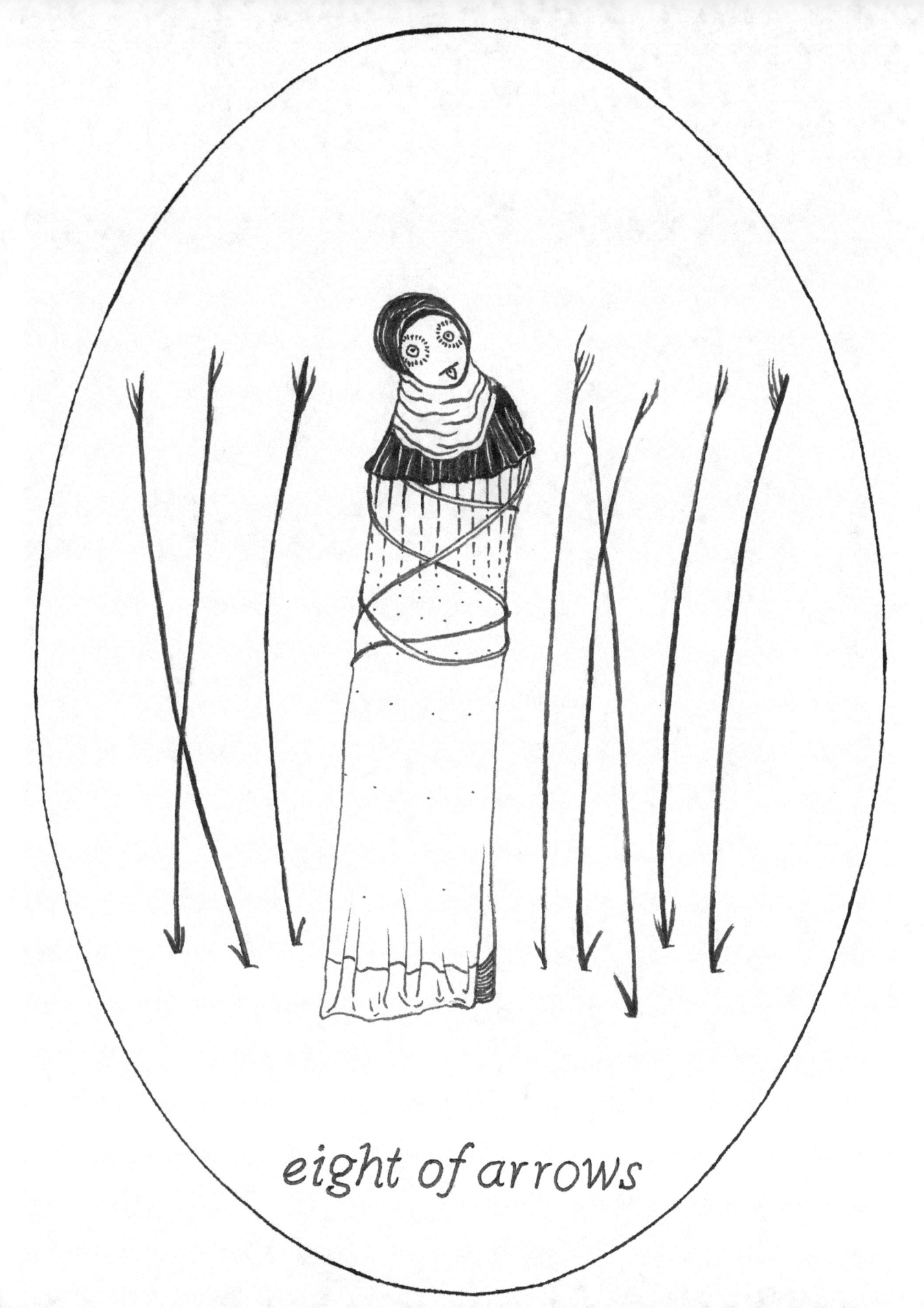

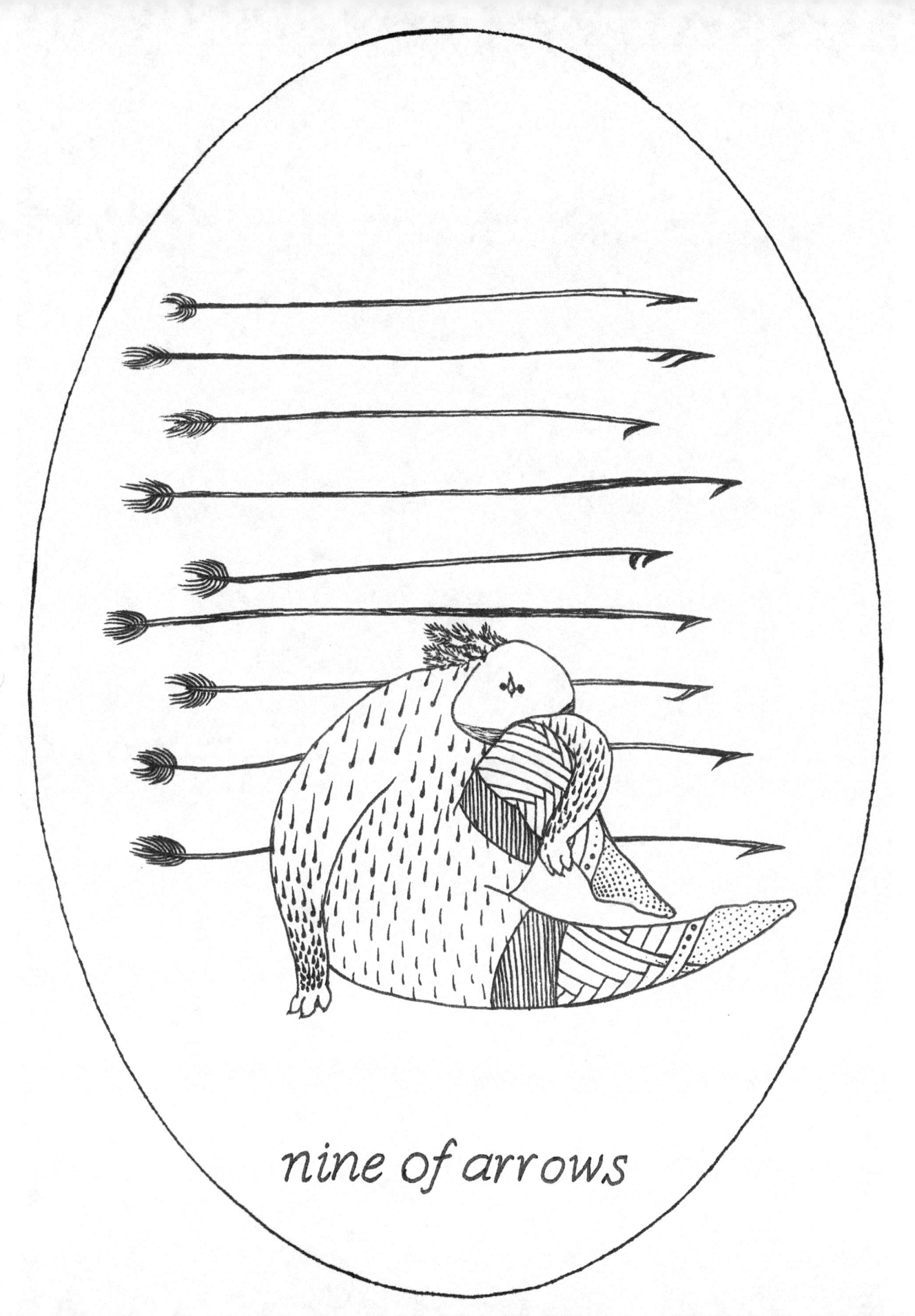

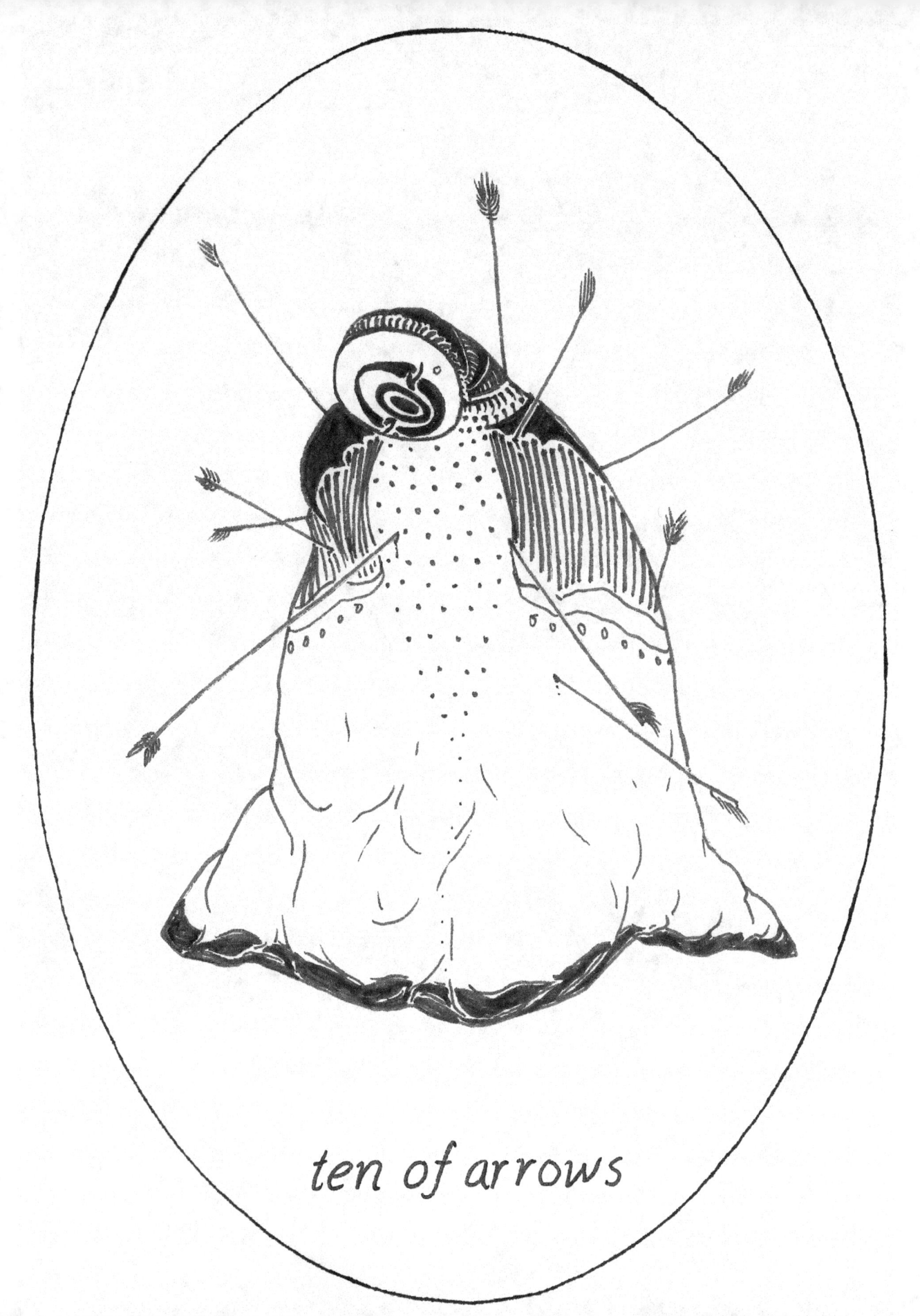

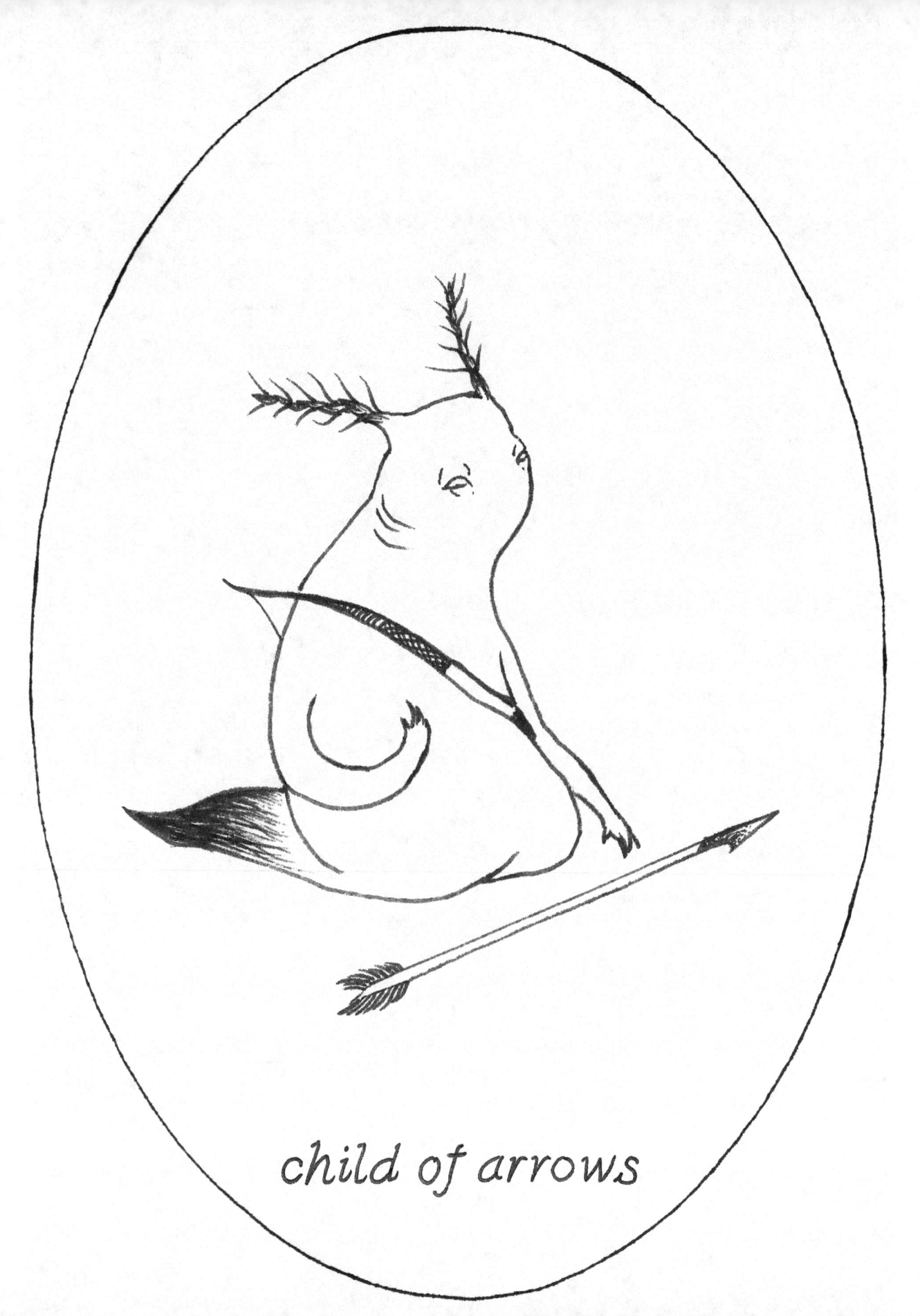

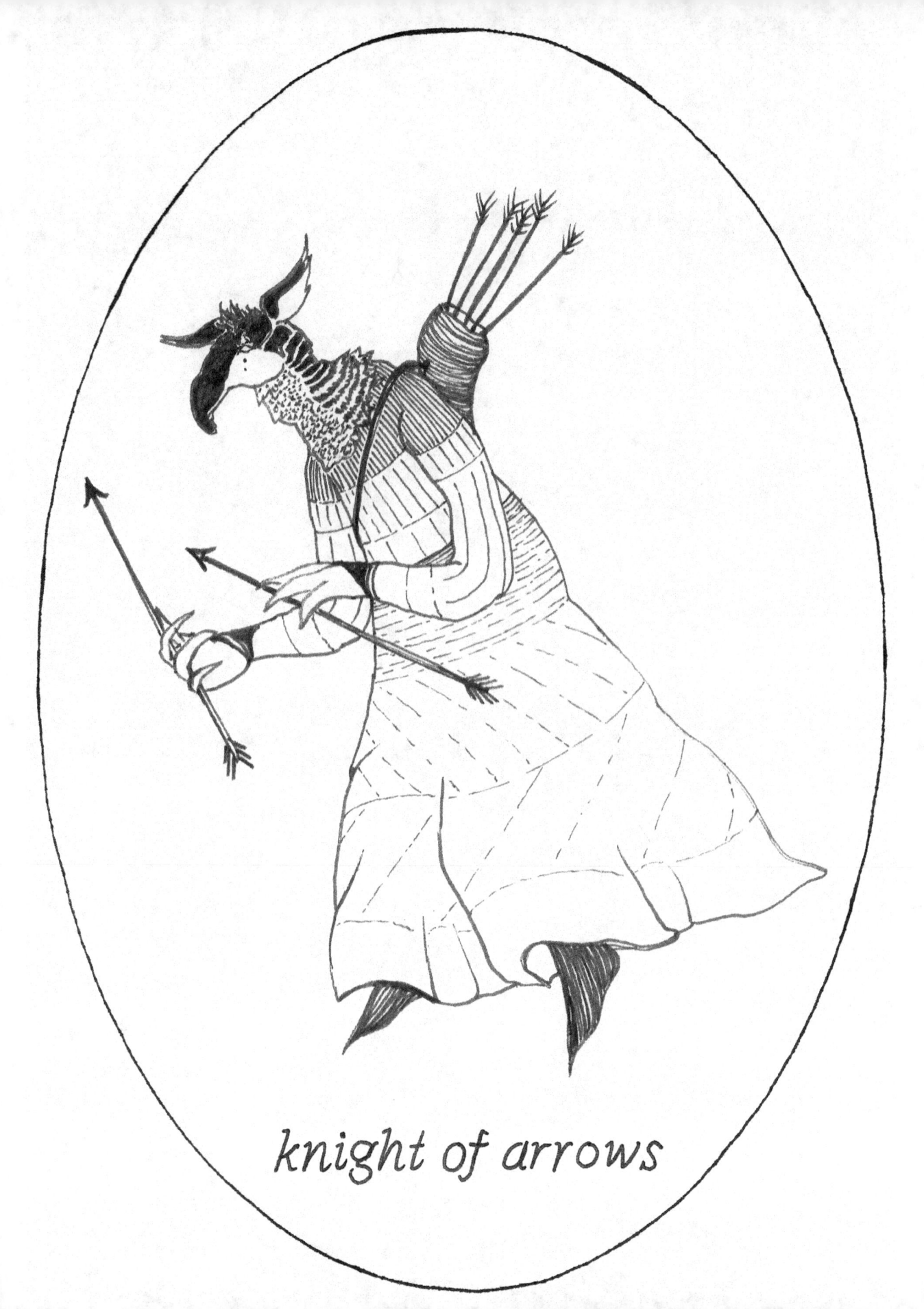

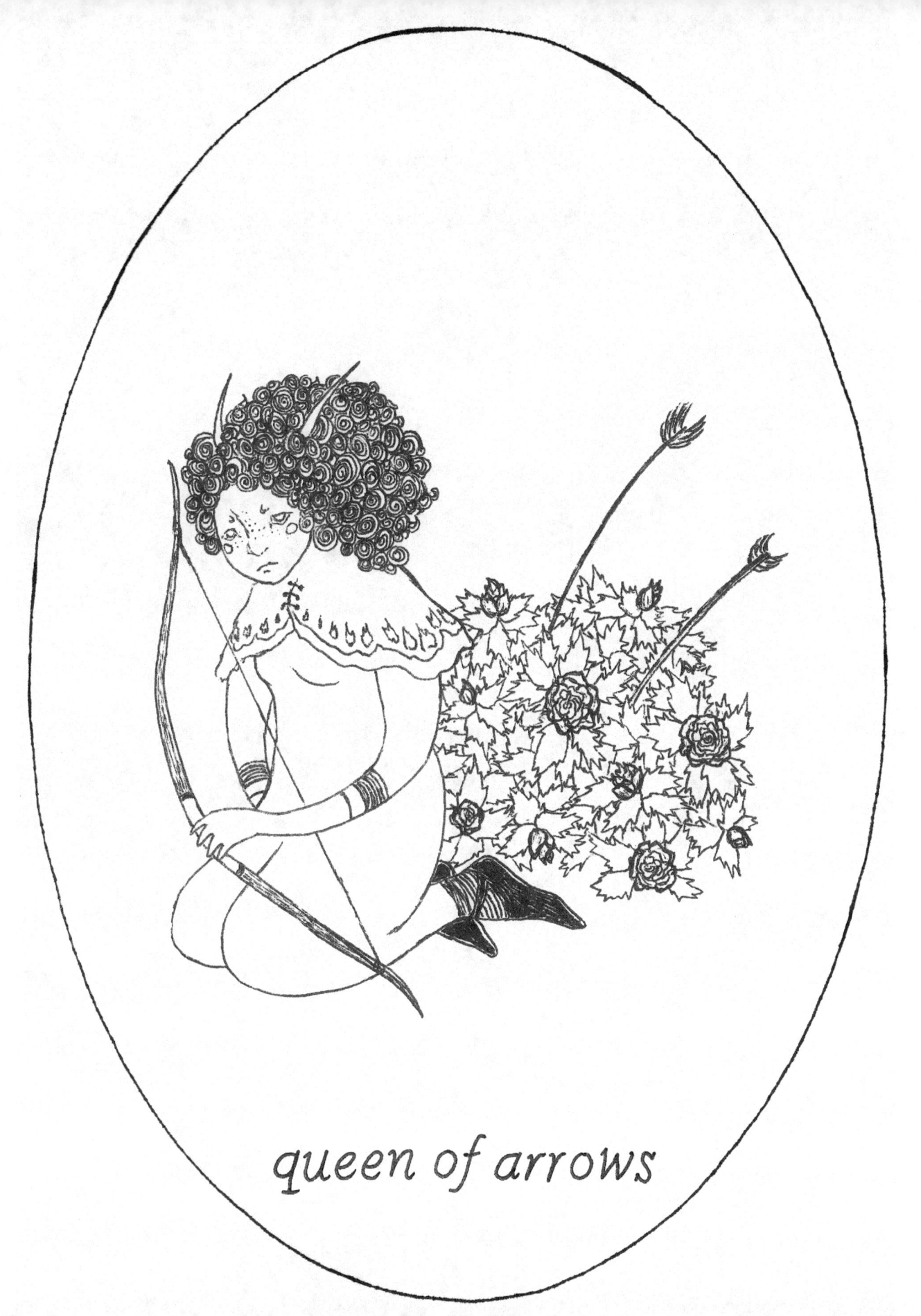

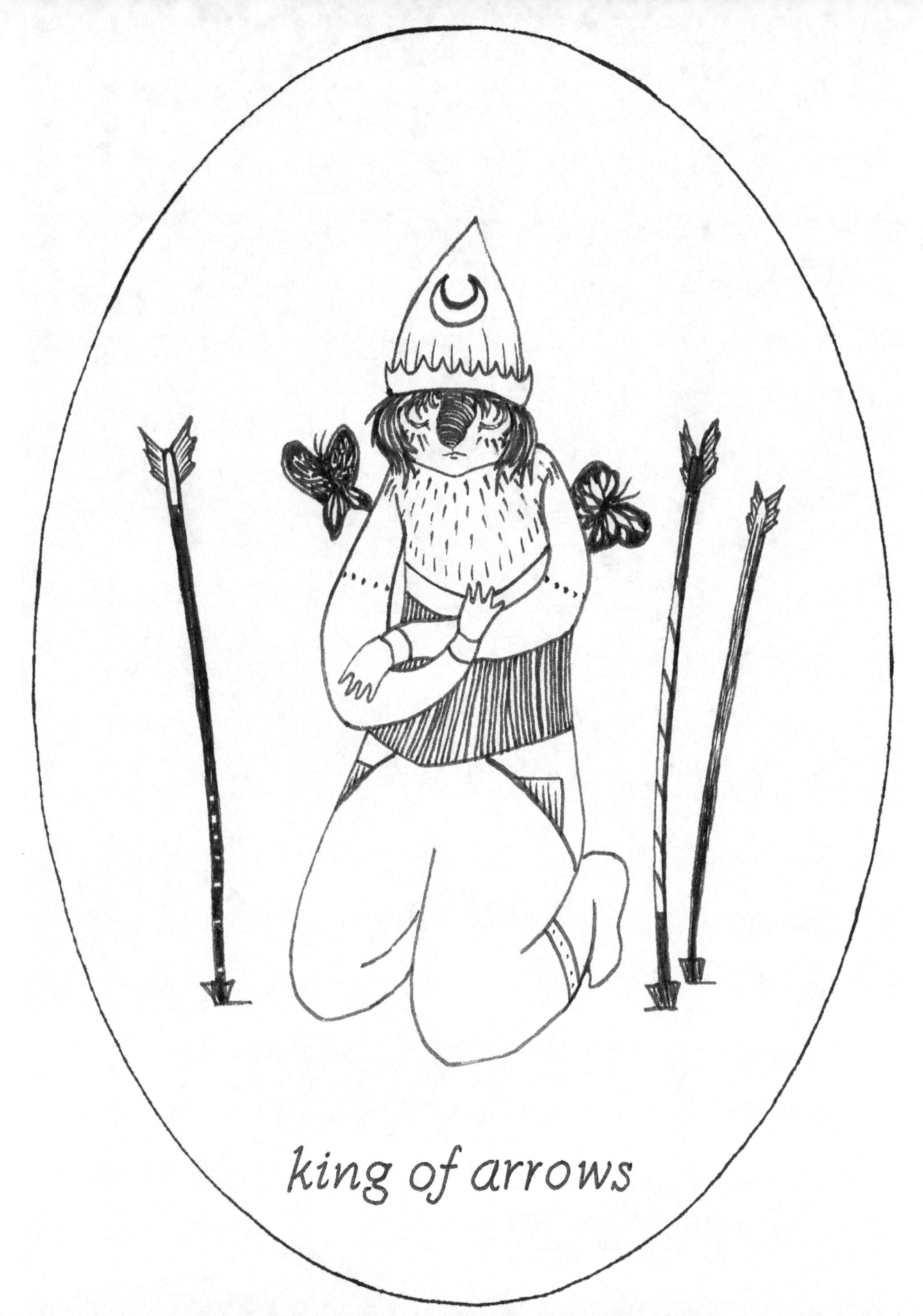

About Peony Coin Archer - illustrator

Peony Coin Archer is a longtime illustrator of esoterica, with two published tarot decks (The Little Monsters Tarot and the Efflorescent Tarot), as well as several gem and mineral decks. She lives in Pennsylvania with a cat and many plants and stones.

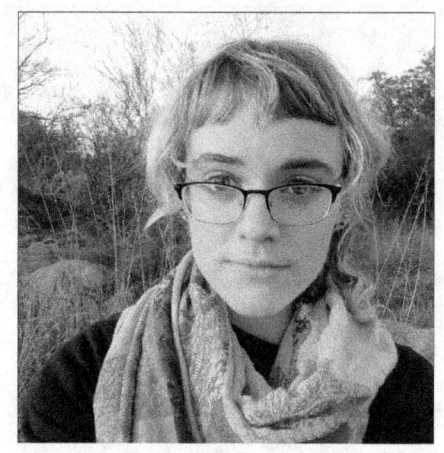

www.ingramcontent.com/pod-product-compliance
Lightning Source LLC
Chambersburg PA
CBHW081112180526
45170CB00008B/2816